Father Desiderius
Desiderian Canon
Egyptian → greek

Female circle
nests inside
8 heads to ~feet~
width hips = 1/5 of height

Symbol of spiritual
Rebirth
square birth

circle square
blood
squaring the circle
bringing heaven to earth
L F
L F
expand
compass
from
F

width of hip

6 palm cubit
hand length one 10th
Height

Key from the lost Canon of
seal of Solomon

Change radius of
circles - chest + abdom
circles

. Female -

Diameter is 5 cubits : Egyptian Royal
Cubit

Fist = 72 large inches Cubit = 1/4 Fathom 18 fists . 24 Egy palm
96 digits Woman = 1 Fathom - 4 cubit, 6 ft. 10
120 small inches Man = 30 head 4.236 30 head
 4 th
Female Golden Proportions . Vitruvius . Fathom

ART PSALMS

Art Psalms

Alex Grey

CoSM
PRESS

ACKNOWLEDGMENTS

It has been an honor to share these verses and rants with creative
and spiritual community around the world, and especially at
the Chapel of Sacred Mirrors, New York City.

Grateful thanks to my friend Eli Morgan, creative director of
CoSM Press, for working with me to design this volume.

Loving appreciation to my wife and dearest friend, Allyson Grey,
for her editorial and design insights.

Special thanks to the team at North Atlantic Books
for shepherding the *Art Psalms* project.

Published by
CoSM Press
542 W. 27th Street
New York, NY 10001
www.cosm.org

In collaboration with
North Atlantic Books
P.O. Box 12327
Berkeley, California 94712
www.northatlanticbooks.com

Cover Art: Human Geometry by Alex Grey, 2008, acrylic on linen, 30 x 40 in.
Chief Editors: Alex Grey, Allyson Grey
Creative Director, Graphic Design, and Production: Eli Morgan

Printed in Malaysia
Distributed to the book trade by Random House, Inc.

Art Psalms is distributed in collaboration with the Society for the Study of Native Arts and Sciences, a nonprofit
educational corporation whose goals are to develop an educational and cross-cultural perspective linking various
scientific, social, and artistic fields; to nurture a holistic view of arts, sciences, humanities, and healing; and to
publish and distribute literature on the relationship of mind, body, and nature.

North Atlantic Books' publications are available through most bookstores.
For further information, call 800-733-3000 or visit our website at www.northatlanticbooks.com.

Library of Congress Cataloging-in-Publication Data
Grey, Alex.
Art Psalms / Alex Grey. -- 1st ed.
p. cm.
 Includes bibliographical references.
 ISBN 978-1-55643-756-4
 1. Artists--Religious life. 2. Art and religion. 3. Spirituality. I. Title.
BL625.9.A78G74 2008

204'.32--dc22

2008022932

1 2 3 4 5 6 7 8 9 TWP 14 13 12 11 10 09 08

North Atlantic Books
Berkeley, California

*Dedicated to the memory
of my father, Walter Velzy,
who started me on
the artist's path, and my
mother, Jane, who nurtured
me all along the way.*

CONTENTS

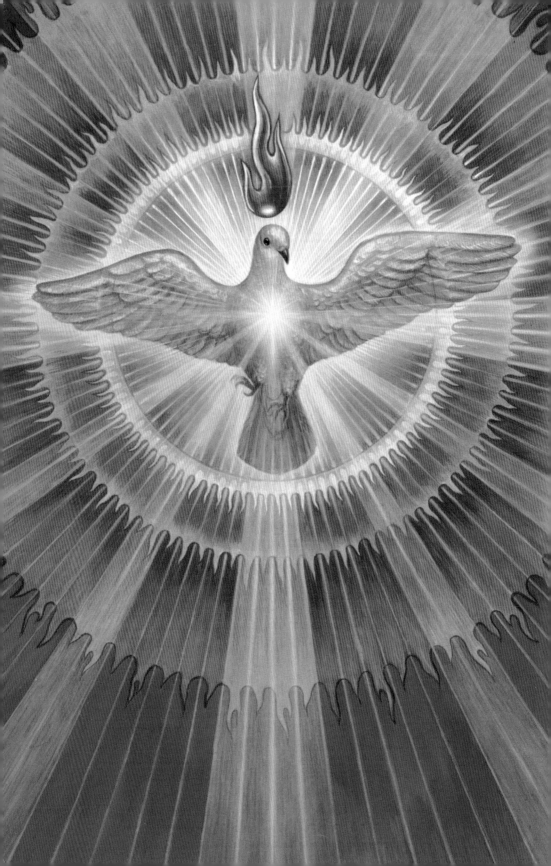

ART PSALMS

Angels dictate mystic rants,
Accompanied by picture prayers.
Precious alloy of art and wisdom,
Forged in a soul furnace,
Beaten on the anvil of discontent
Until shaped suitable for the altar
In the Church of Vision
Where creativity is religion.

We seek through art
To recover our center,
To remember our soul's task,
To stop sleepwalking in confusion,
To stop managing our depression,
To harness the passion of inextinguishable love,
To find the One Godself,
Hidden throughout creation.
Art is the scab healing the wound
Of the separate-self illusion.

Creators aligned with Divine Will
Make the soul perceptible.
Artist priests with minimal dogma
Transfix, transform, and evolve
The chaotic melding of cultures,
Through the dross of ego
To superconscious fusion
With the Nature-field.
Suddenly, Holy Spirits are everywhere.
Saviors invent solar panels,
Restore species, and habitats mushroom,
Alchemically transmuting earthly desecration.
All creatures, brothers and sisters,
Planet as Holy Temple.

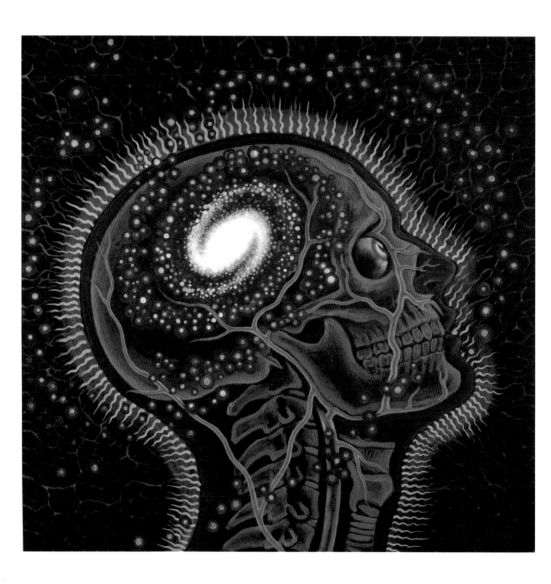

Universe

uni : one
verse : poem or song

Godself sings one song
Moment by moment,
With infinite variations.

All sounds, one symphony.
All visions, one icon.
All beings, one actor.

O Microcosm,
Hear with God's ear,
See with God's eye.

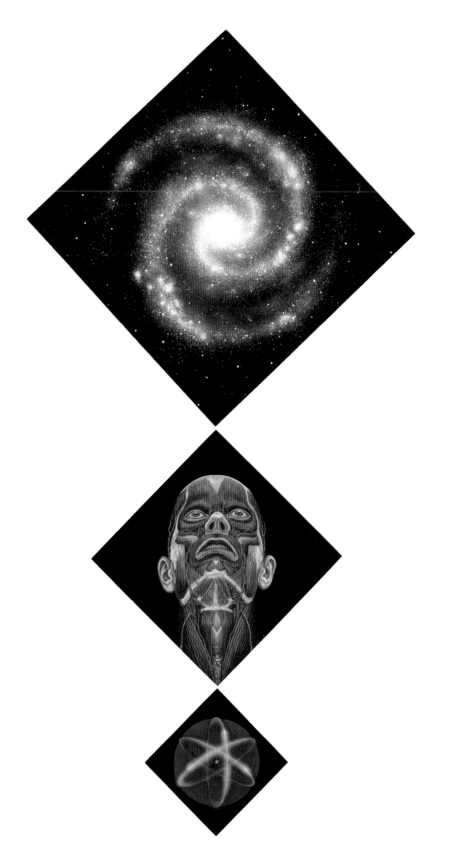

THE ONE

Fifteen billion years ago,
Before the beginning,
In the Studio of Eternity
There was a blank canvas,
Nothingness,
Pregnant with the possibility of Everything.
Then—A MIRACLE!
Our Collective Being,
The Divine Artist—the Creator God,
Aching to express, to exist,
Exploded itself/ourself into a cascade of lightselves.
A cosmic orgasm
Big-banged us into creation,
Perfect in ratios, rhythms, and forms.
The Universe is a storm of light emerging,
Ever birthing, ever dying
Plasma selves, atom selves, molecular selves, cell selves,
Conscious lumps of DNA.
Ascending selves scaling evolving chains of Being.
Souls inside brightening,
Hardening into botanical and biological bodies.
Plant self, animal self,
Myself, yourself, ourselves,
Family selves, city self, nation self,
An earth full of eyes sees everything on earth
And we are that!
Planet self, star self, galactic self,
Self as galactic cluster,
Self as entire web of Cosmos
With amnesia.
Our current artistic dilemma is to wake up
To the truth that we are the One Godself,
Creating the Universe—Every day.

THE PLAN

1. GOD CREATES THE COSMOS WITH LOVE.

2. WHEN WE CREATE WITH LOVE WE ALIGN OURSELVES WITH THE GOD FORCE.

3. THE COSMOS AND OUR WORLD IS GOD'S EVOLVING CREATION, AN UNFINISHED MASTERPIECE WE EACH CO-CREATE.

4. LOVE WILL GO TO ANY LENGTH TO FULFILL ITS CREATION.

5. WE ARE EACH A FINITE MIRROR OF GOD'S INFINITE CREATION.

6. TO SEE THROUGH APPEARANCES TO GOD'S TRANSCENDENT PRESENCE BEATIFIES AND TRANSFIGURES OUR EXPERIENCE OF GOD'S IMMANENT CREATION.

7. CREATING SACRED SPACE MIRRORS GOD'S CREATION.

8. OUR CHALLENGE AS CO-CREATORS IS TO MIRROR GOD'S LOVE AND BEAUTY IN ALL OUR CREATIONS.

9. ALL ACTION IS CREATION MORE OR LESS CONSCIOUS.

10. THE PLAN IS TO UNMASK THE ILLUSION OF SEPARATION.

11. THE PLAN CAN ONLY BE ENACTED BY BECOMING CONSCIOUS CO-CREATORS.

12. REFLECTION IS THE PROCESS BY WHICH WE INCREASE AND UNLEASH OUR HIGHER, GREATER, DEEPER CONSCIOUSNESS.

13. INFINITE CONSCIOUSNESS IS A MIRROR OF GOD'S PRESENCE, BOUNDLESS AND ALL INCLUSIVE.

14. INFINITE MIND KNOWS THE PERFECTION OF ALL AS IT IS IN EACH MOMENT, AND FEELS THE INFINITE LOVE THAT SEES AND ACTS ON THE UNFINISHED MASTERPIECE TO CREATE A WORLD THAT MORE EFFECTIVELY MIRRORS GOD.

15. THE COSMOS AND OUR OWN LIVES ARE GIFTS OF LOVE FROM THE CREATOR.

16. A PERMANENT THANKFULNESS FOR THE GIFTS IS ONE BENEFIT OF REALIZATION.

17. REALIZATION IS AWAKENING MORE OR LESS TO THE PLAN AND OUR OWN ROLE IN THE EVOLVING CREATION.

18. CREATIVITY IS A SACRED MIRROR AND PATH TO REALIZATION.

19. A NEW ALLIANCE OF SPIRIT AND HUMANITY IS BEING CREATED THROUGH SACRED ART.

20. SEEING AND BEING IS A CREATION.

21. CREATIVITY IS HOLY, A PATH TO RECOVER OUR WHOLENESS, A SPIRITUAL PATH CAPABLE OF CATALYZING OUR SELF-REALIZATION.

22. BECOME A WORTHY CONDUIT OF GOD'S LOVE AND CREATIVE POWER OF REALIZATION.

23. LIKE A LIGHTNING FLASH, WHEN CONDITIONS ARE PRESENT, THE LIGHT SUDDENLY FILLS US, ILLUMINATING THE WORLD FOR AN INSTANT.

24. MEET GOD IN THE STORM OF LIFE AND BE A CONDUCTOR OF DIVINE RADIANCE.

25. THE EXAMPLE OF YOUR LIGHT CAN SET OFF A CHAIN REACTION OF PENTACOSTAL SOULFIRE.

26. SOULFIRE IS THE PASSION TO PERFORM ACTS, TO CREATE IN ACCORDANCE WITH DIVINE LAW.

27. THE TIMELESS ENTERS THE CREATIVE FIELD OF HISTORY WHEN CALLED, AND HUMAN RELIGION MIRRORS THE EVOLVING WAVES OF SPIRITUAL ALLIANCES.

28. NOW RELIGION IS THE BLANK CANVAS OF CREATIVE ENERGY. THE NEW ALLIANCE HAS ANNOINTED CREATIVITY AS A WORTHY CONDUIT.

29. NOW IS ART A BLESSED PATH TO INSPIRATIONAL ECSTASY, THE FUSION OF SPIRIT AND MATTER FOR THE UPLIFTING.

30. THE GREAT UPLIFTING OF HUMANITY BEYOND ITS SELF-DESTRUCTION IS THE REDEMPTIVE CALLING OF ART.

31. REMOVE THE BLOCKS TO YOUR CREATIVE PLASMA STATE. THE HEART IS A SAFE CONTAINER FOR SUCH A POWER.

32. THE PLASMA STATE OF SOULFIRE IN THE HEART IS THE WELDING TORCH OF LOVE FUSING GOD AND HUMAN TOGETHER.

33. A WELL-LIT SOULFIRE CAN BURN AWAY OBSTACLES TO THE DIVINE FOR THOUSANDS OF YEARS.

34. SACRED SPACE MIRRORS THE HEART AS A PUMPHOUSE FOR COMMUNAL SOULFIRE.

35. THE CREATION OF SACRED SPACE IS A CALLING OF THE HIGHEST AND DEEPEST URGENCY AS A NEW MODEL FOR POSSIBLE FUTURES.

36. HUMANITY MUST BE AWAKENED, AND CREATIVE SPIRITUALITY HAS A VITAL AND HEALING ROLE IN THE ARCHETYPE OF AN UNDOGMATIC AND LOVINGLY ECSTATIC RELIGION. ALL ARE CALLED TO SEE THEIR OWN DIVINE BEAUTY AND UNFINISHED MASTERPIECE STATUS.

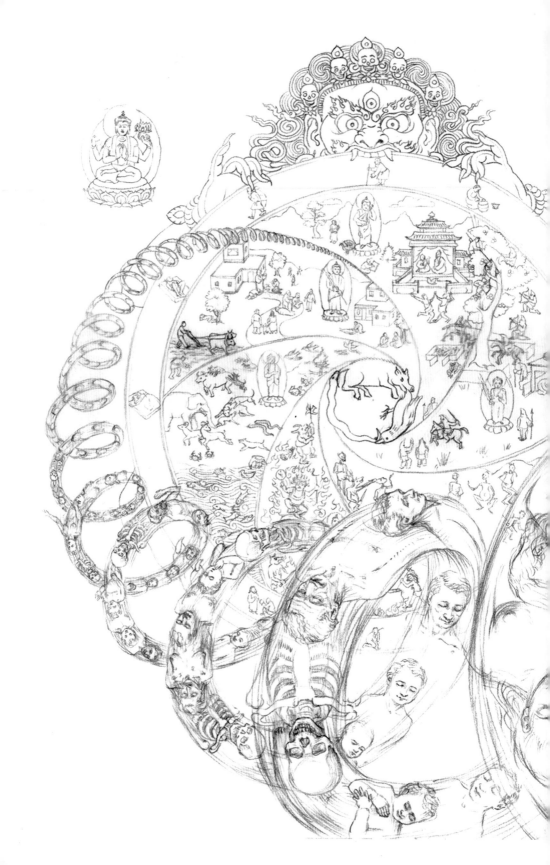

37. BUILDING SACRED SPACE TOGETHER IS A TASK BEYOND OUR INDIVIDUALITY TO WHICH WE CAN DEDICATE OURSELVES AND PROVE THE POSSIBILITY OF PEOPLE GETTING ALONG AND MAKING SOMETHING BEAUTIFUL TOGETHER.

38. THE DAWN OF PLANETARY CONSCIOUSNESS IS UP TO EACH OF US AS ARTISTS OF INNER LIGHT.

39. OUR COMBINED LIGHT CAN BLAST THE PSYCHO-EVOLUTIONARY PROCESS INTO CREATIVE OVERDRIVE INVENTING NEW WAYS TO SAVE THE TEMPLE OF LOVE, OUR EARTHLY LIFEWEB.

40. ALL CREATURES ARE HOLY AND EACH ARE GOD'S CHILDREN. REVERE AND PROTECT THEM AND THEIR HOME.

41. HUMANITY, GRIEVE ACTIVELY OVER YOUR SLAUGHTER OF NATURE BY COMMITTING ACTS OF COLLECTIVE PRESERVATION.

42. PRESERVATION AND RENEWAL OF WHAT REMAINS OF THE LIFEWEB IS STILL A POSSIBILITY.

Study for D.L.

ALGray

1995

43. SCIENCE AND SPIRITUALITY MUST COMBINE FORCES THROUGH ART, BRIDGING KNOWLEDGE WITH WISDOM, ENTERING HISTORY THROUGH CREATIVE ACTION.

44. FORGIVENESS OF HUMANITY BY THE WEB OF LIFE WILL BEGIN WHEN RITUALS OF CONFESSION OF WRONGDOING ARE ENACTED WORLDWIDE AND PRAYERS FOR HEALING THE LIFEWEB ARE COLLECTIVELY ENGAGED.

45. WHETHER OR NOT THE NEW ALLIANCE OF COLLECTIVE INTELLIGENCES CAN SAVE THE UNFINISHED MASTERPIECE OF LIFE ON EARTH IS UNKNOWN; HOWEVER, THE PLAN IS UNDER WAY.

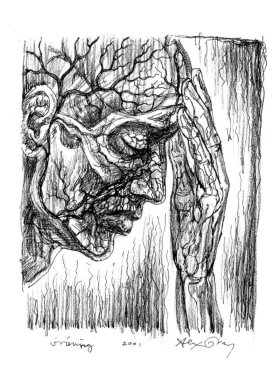

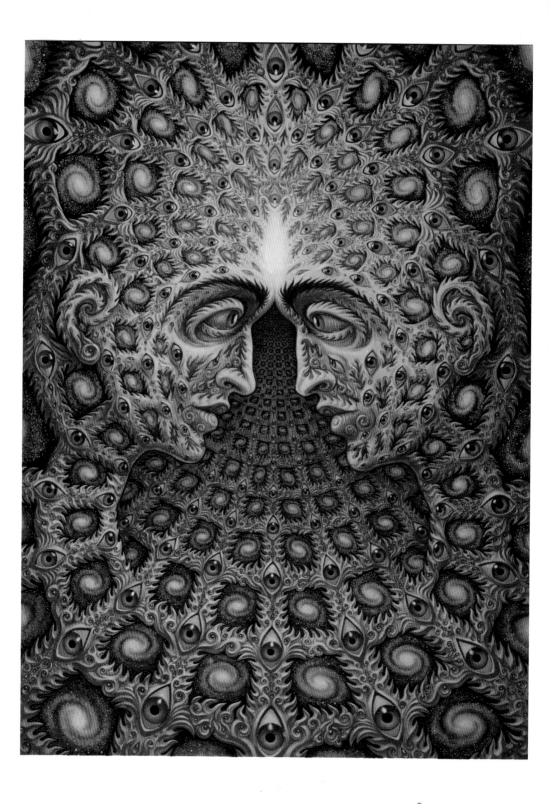

SOUL MARRIAGE

*A commitment to your own
and the world's transformation*

For the benefit of

Myself and all beings,

I, _____,

(my ego & personality)

Do solemnly swear

To love, honor, and

Obey my Soul,

My path to realization

And relationship

With a higher, deeper

Creative power,

For better or worse,

For richer or poorer,

In sickness and

In health,

From now and

Forever more.

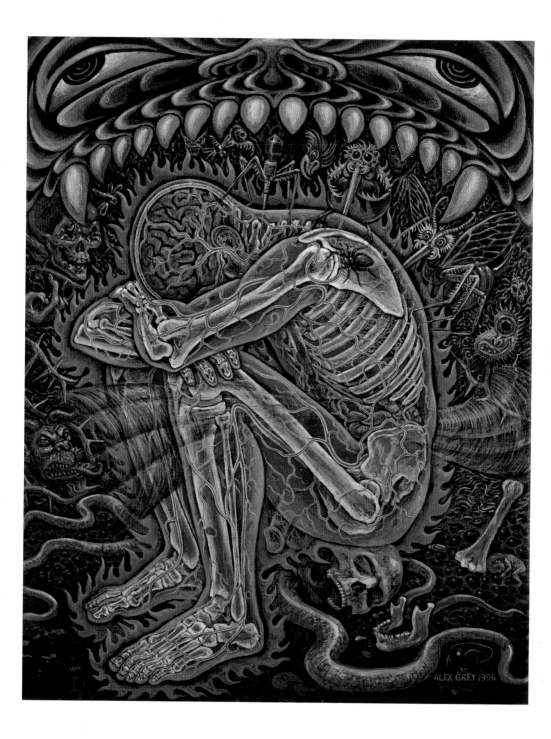

THE PRODIGAL ARTIST

Centuries ago, the artist left the church, wandering
away from the constrictions of religious dogma,
a cruel father and a distant mother, in pursuit of freedom
and personal identity. Departing from the secure but
stifling home of traditional sacred iconography, the artist
gambled creative richness on formal innovations, and
ambiguous or transgressive subjects. The prodigal artist
walked the countryside into the town of bourgeois homes,
visiting every tavern, tasting expensive liqueurs and cheap booze.
In a haze of romantic rebellion and stiff-necked
egotism, the artist blurted out drunken hallucinations
and bad dreams, wasting themselves and their viewers.

Now, we eat at the trough of artistic swill next to greedy swine,
a serving of fashionable nihilism, appealing to every base and
animal instinct. The contemporary artist commits suicide,
hovers in irony and ambiguity, worships mammon, decorates
the cell walls of an absurd existence with excrement, or vows to
find a way home to the authentic sacred—not a blind return to
the ancient ways, not reverting to former outdated strategies,
but with insights gained after traipsing through every ism.

The prodigal artist rambles into the future, bringing
wisdom of personal experiences, mindful of humanity's
capacity for catastrophe, yet also for creative renewal.
Humbly, the artist approaches the spiritual home.
Will the door be opened? Can the spirit be served in
some lowly way that befits the artist's ignorance?
The doors of light burst open and angels herald the return.
Invited into a palatial studio specially prepared, the artist is
given tools of the trade, and bidden to begin joyful work.

Seven Statements on Mystic Art

1. Mystic Art is spirit expressed into matter. A mystic artist receives and transmits revelation, providing their art as a medium for messages from the divine matrix of Creation.

2. Mystic Art establishes a visual covenant with receptive viewers, validating the boundless state, and opening a portal back to Spirit.

3. The highest motivation for creating art is Transcendental Inspiration, which naturally arises out of Spiritual Intoxication, the ecstatic love of God, and the intention to share visions to benefit others.

4. Mystic Art affirms the holy mystery and the ideals of truth, goodness, and beauty. No other artistic ideal can fulfill the longing soul like the creation and appreciation of relevant Sacred Art.

5. Mystic Art exudes spiritual nectar, luminous food for the soul. Busy eyes taste the nectar and return for sweet nourishment.

6. By projecting forms which are crystallized visions of spiritual illumination, Mystic Art helps engineer higher mind states in the viewer. Relevant Sacred Art renews the subtle light body surrounding and interpenetrating our physical body. Our subtle body is purified, uplifted, and healed by visually absorbing deity and ideal forms.

7. Presence of Ultimate Reality absorbed through Mystic Art helps magnetize the viewer toward their own spiritual template and Supreme Identity.

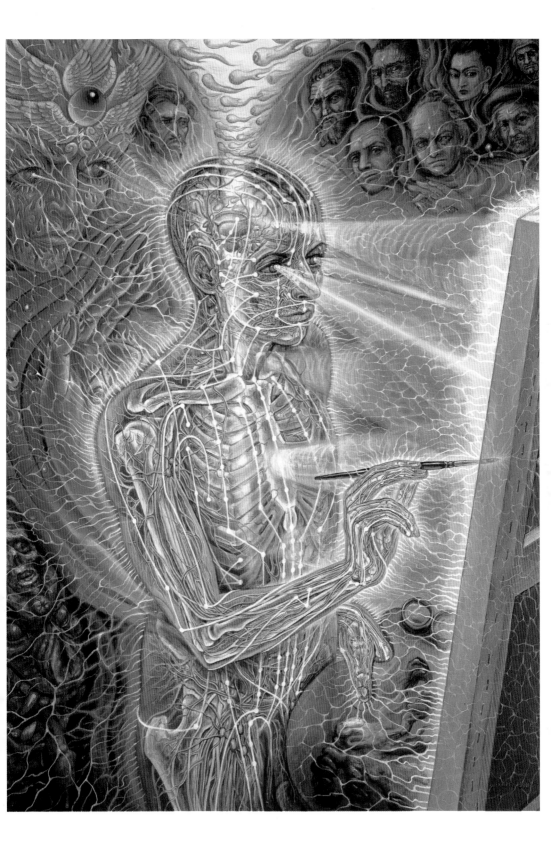

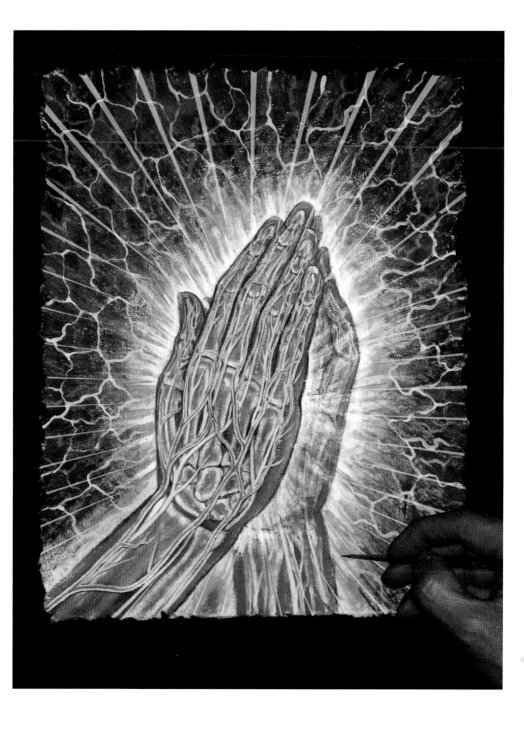

ARTIST'S PRAYER

Creator of the Universe,
How infinite and astonishing
Are your worlds.
Thank you
For your Sacred Art
And sustaining Presence.

Divine Imagination,
Forgive my blindness,
Open all my Eyes.
Reveal the Light of Truth.
Let original Beauty
Guide my every stroke.

Universal Creativity,
Flow through me,
From my heart
Through my mind to my hand.
Infuse my work with Spirit
To feed hungry souls.

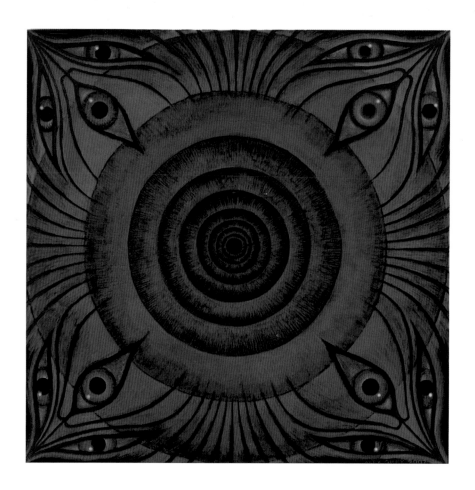

The Seer

From the caves of Altamira
To a New York studio,
The Seer has inspired the artist
With Vision's unceasing flow.

The Seer is the soul of the artist,
Magus through ages untold,
Transmuting the lead of matter
Into bullets of spiritual gold.

The ego picks up the weapon of Art.
Childlike, it plays with the trigger.
Blowing the head off its contracted self,
Awareness is suddenly bigger.

By slaying the ego and stunning
The chatter of thoughts as they rise,
Great art shuts out distractions,
Delighting the heart through the eyes.

The Seer is the soul of the artist,
Revealing the Mystery as form,
Advancing our civilization
By inventing and destroying the norm.

The redemptive Sorceress, Art
Can heal the nausea of being,
Opening vistas of hope and beauty,
Revealing deep patterns of meaning.

The function of Art is to stop us
And take us out of our skin,
Unveiling the spirit's pure nakedness,
Without beginning or end.

The Seer is the soul of the artist,
Gaze fixed on primordial perfection.
Radiance emerges from emptiness,
Each point of light etched with affection.

The boundless Void, open and formless,
Is the basis of all creation.
Visions appear and then dissolve,
Reinforcing this realization.

From beyond the vision descends.
From within the vision arises.
Coalescing in the divine imagination,
Source of continual surprises.

The Seer is the soul of the artist.
The Maker is the artist's hand.
In the studio their conversations
Translate a timeless command.

These dialogues of Maker and Seer
Weave together matter with soul,
Consecrating the practice of art
As speech of the ineffable.

Art-making transforms the artist,
And to any hearts truly under
Creation's intoxicating spell,
The Seer transmits holy wonder.

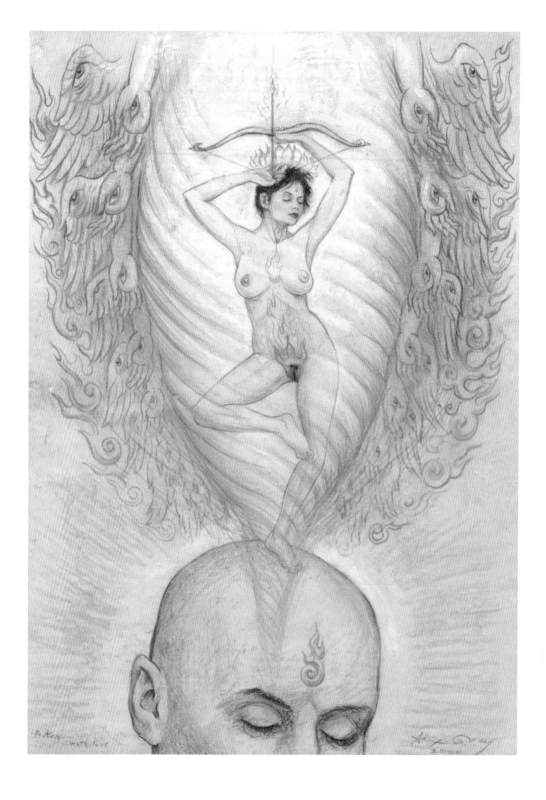

BITCH GODDESS BEAUTY

The artists stroke and slap at matter,
Sensitively, like lovers around a clitoris
Of the supreme Bitch Goddess, Beauty.
She, locked in passion
With the upright lingham of truth,
Licks and slowly writhes, coaxing
Fountains of steaming ejaculated bliss
To impregnate her ecstatic devotees
With the flaming semen of good vision.

Embryonic artworks grow
In the womb heart of the artists,
Until the fever of making seizes their limbs,
And they deliver their art through labors of love.
Fresh art, still warm from creative birth,
Enters new eyes, awakening medicinal soul resonance.
The artists, never resting,
Follow after the undulating Bitch Goddess,
Ever slipping away until they clutch her.
Arousing her passion, they open their hearts,
Awaiting the next divine conception.

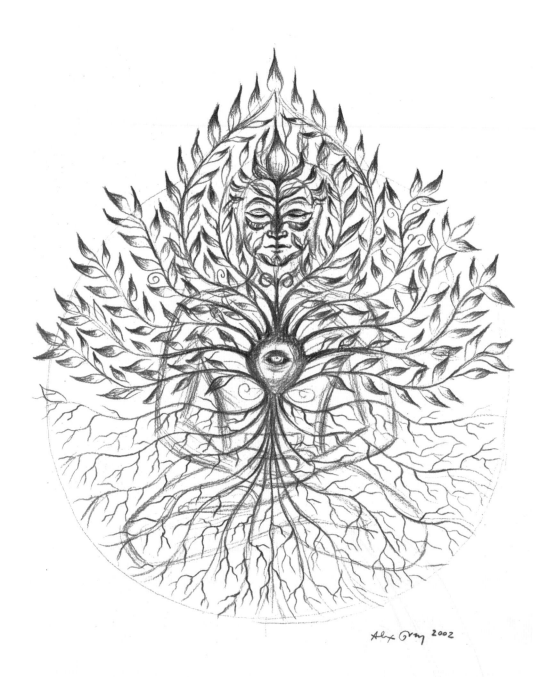

Nature of an Artist's Soul

The artist's soul is like wildflowers growing in a ditch.

The artist's soul is like the bee, busily gathering sustenance from God's beauty, returning to the nest of the studio and transforming the pollen of inspiration into the honey of art, a sweetness for all.

The artist's soul is like a mountain, indistinct and mist-covered. It sometimes fades from view, as if not there at all.

The artist's soul is like a tree with roots in the Heavens and limbs branching to earth, explosively blooming creation.

The artist's soul is like a toxic waste dump, feeding the culture back its own carelessly cast-off poisons.

The artist's soul is like the outrageous colors of fall, the dying plunge of beauty, bleeding over everything.

The artist's soul is like a deer darting out in front of our philosophical car. In a moment of shock we swerve, wreck our car, the deer escapes unharmed, and we need a new philosophy.

The artist's soul is like a hidden spring leaking up through the ground, making pools in the forest—both mosquitoes and tadpoles thrive in it.

The artist's soul is like a rocky field: plow it and you'll bust your plow.

The artist's soul is like a wasp which builds its nest on your house—it's beautiful but scary.

The artist's soul is like a bear—big and dumb. Get out of its way. It does what it pleases.

The artist's soul is like the birds which herald a new dawn, up before everyone—Their song is rarely heard breaking the still silence of night.

As the sun emerges from the horizon, inflaming the world with living color, sharp orange and pink on the cloud—the artist's soul is like that.

The artist's soul is like the sky and clouds, constantly building amazing shapes, now wispy, now tempestuous, completely blocking the source of light, then dissolving into brilliant clarity.

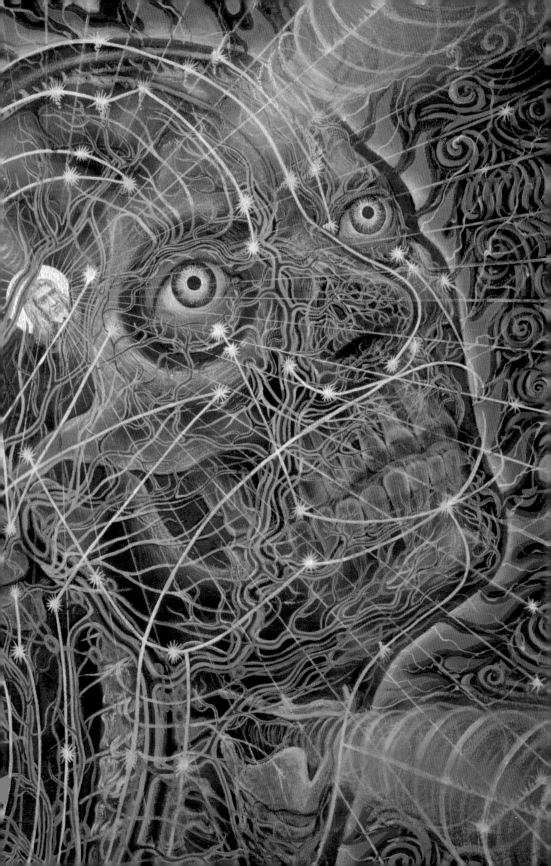

THE INNER ARTIST

The inner artist guides us toward actions that serve our soul's emergence.

The inner artist is not the voice of reason.

The inner artist can have wild and impossible ideas.

Artists are most themselves when they are out of their minds, transcending the ego skirmishes of conceptual thought, and intuitively relinquishing control to the greater Creator.

The inner artist is not the voice of comfort.

The artist challenges us to work at the peak of our potential and guides us toward greater beauty, meaning, and love.

What decisions in our lives and work would satisfy and fulfill the artist in our soul?

If our lives are the most important canvas, let the inner artist guide the strokes and make the best possible picture of it.

If our lives are the most important theatrical production, let the inner artist unfold the plot, making decisions that bring excitement, wonder, and revelation into life.

How does every nuance and whisper of color, design, or music affect our feelings?

Our artist temperament is deeply penetrated by the experiences of all the senses—not just the five senses, but the moral and spiritual sense, as well.

The artist soul is open to and pounded by all the forces of creation, yet instead of shattering, is compressed into a radiant diamond.

The inner artist is not only sensitive, but takes action to make each project, and life itself, into a beautiful and meaningful creation.

The inner artist finds inventive ways of sharing gifts, inviting relationships and participation in life.

The inner artist has faith in and surrenders to God's limitless creativity, combining aspects of both the mystic and the engineer to bring spirit into form.

Listen to the inner artist and begin your Magnum Opus.

BLESS YOUR EYES

Your eyes are blessed openings,
Taking in whatever light brings.
Treat eyes kindly, feed them well,
They excitedly glisten and lovingly swell.
Show them the worst all over again,
They shrink into hollows of mortal skin.
Bathe your eyes in images Divine,
All Heaven unfolds, the opposites combine.
Your eyes become temple domes for the Pleiades,
Crystalline mandalas inhabited by Deities.
Blessing every moment you see
As glimpses of eternity.

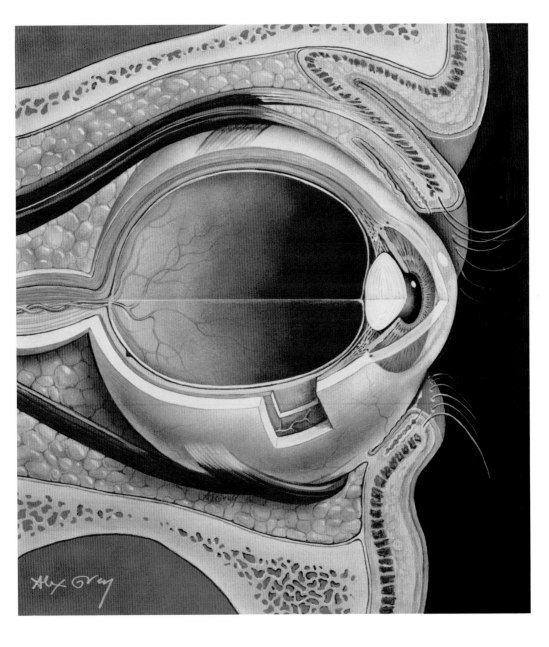

Let Love Draw the Line

Our minds are artists,
Always drawing lines,
Making decisions, differentiating
One thing from another.
Drawing the boundary line
Between this form and that
Is what the mind does.
This is how we think.
We define
By drawing the line.

And by drawing the line
The artist inside makes a magnificent Illusion
Of distinct and various forms,
Nicely separated by boundary lines.
But is this picture of reality, drawn by the mind,
A picture of truth?
We notice differences.
We dramatize.
We exaggerate.
We add colors.
We make it beautiful.
We make it ugly.
We separate.
We oppose
When we draw boundary lines.

Prior to all the lines,
The Uncreated blank page
Could be the Ultimate Ground.
Indeed, prior to all lines,
The stainless ground,
The infinite Vastness,
Is perfect just as it is.
Yet how can we know it,
How can we see it,
How can we share it,
Unless we draw a line around it?

The Soul is the bounding line,
The bonding line
Between the Vastness of ground
And the limits of body.
The Soul is the aura
Welding figure to ground.
The ground is boundless.
We are framing the boundless.
The skin surrounds and binds the ground,
The holy ground that knows no bounds.
How can the ground that knows no bounds
Be bound within a skin surround?

To speechlessly and artlessly
Behold the Infinite One,
The inseparable ground
From whence all forms are drawn,
Dissolves the tyranny of separation,
The war of opposites,
Caused by drawing lines.
Recognize the still, serene
Hub of the turning cosmos
As the deathless light of love
In your own heart.
The lines this light draws include everything,
Creating patterns which connect.
The lines it draws weave the world together
And arise from the boundless ground.
All beings and things are radiances interweaving,
Seamlessly welded to the boundless ground.

Between our fear of failure
And our ultimate potential
We are called to action.
A line must be drawn.
Commit to Realization
And experimentation,
Stay in the Uncreated Source of Creation.
Leave the critics behind.
Let Love draw the line.

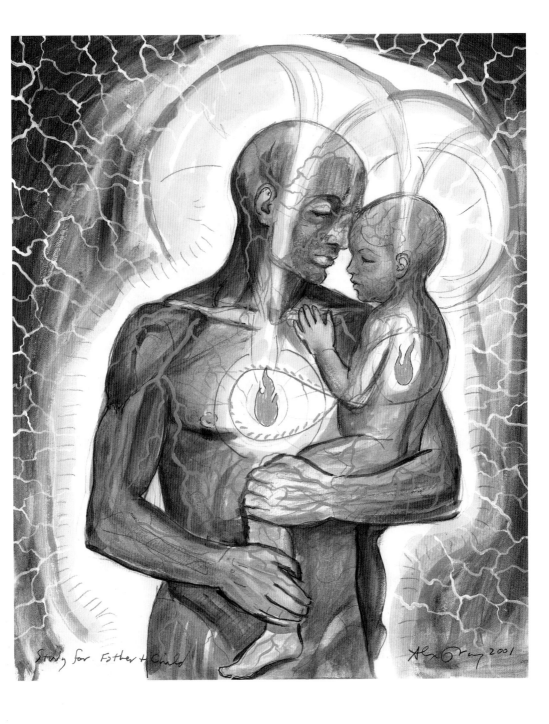

Study for Father + Child

Praise Be the Song of Art

To praise the Creator
We sing our songs.
God of Gods, Source of Sources,
Moving atomic and kosmic forces.
Hearts are pumping bloody praise
Through our veins.
Your nameless name
And boundlessness
Echo in each beating breast,
Drumming your eternal Song.

Meaning counters meaninglessness,
And dreams make sense uncommonly deep.
Your fury most mysterious,
Your voice we hear in every breath.
I can't be worth your trouble, Lord,
I have such flaws and qualities bad.
Can't concentrate and remain with you.
Mind wanders away,
Finds things to do.
God help me hear your Song.

Only You can write a poem.
Only You can paint a masterpiece.
Only You radiate from works of genius.
The artist becomes transparent to God.
An empty grail filled with God's light,
Nectar of the Arts.
A single secret drop
Can change the course of Art History.
Entire Cultures change overnight from one drop.

To see through a drop of spiritual light
Makes infinity visible
And is the consolation of the Soul
In its painful task of flight and descent
From Heaven to Earth to Hell and back.
The soul dreams itself awake,
And what strange dreams you artists make.
Culture is our collective dream.
God's promise of union with the All
And History's nightmare of our fall
Echo from unconscious ground
Through poet's tongue
And musician's sound.
The painters touch and smell the vision
While millions doze, watching television.

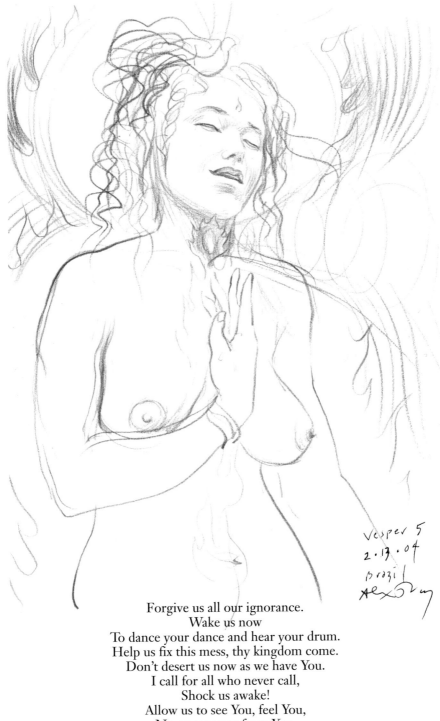

Vesper 5
2·13·04
Brazil
Alex Grey

Forgive us all our ignorance.
Wake us now
To dance your dance and hear your drum.
Help us fix this mess, thy kingdom come.
Don't desert us now as we have You.
I call for all who never call,
Shock us awake!
Allow us to see You, feel You,
Never separate from You.
Let us love You with all our creative heart
And sing You through our Song of Art.
Praise, Praise be the Song of Art.

45

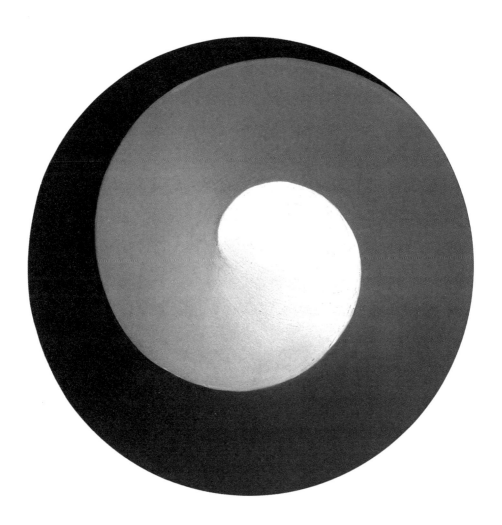

The Polar Unity Spiral symbolizes the experience I had the first time I took LSD. When I closed my eyes I was in a dark, helical tunnel going toward the light, visible just around the bend. The tunnel experience was a spiritual rebirth canal that led to the insight of Polar Unity. The Polar Unity Spiral expresses the transformation of extremes into each other. Polar Unity is the mind's capacity to embrace simultaneous contradiction without conflict. Polar Unity is the mental resolution of the conflict of opposites by transcendent insight into their basic interdependence. Polar Unity is the law of the dimension beyond and connecting all space/time. Polar Unity is the revelation of our spiritual connectedness with every other being and thing. Polar Unity is the oscillation of the infinite love energy of God. Polar Unity is at the core of all religious and mystical experiences. Experiencing the unity of Self with God promotes healing and perfection of mind, body, and spirit. The true insight of Polar Unity leads to an ethics of love and active compassion. To embrace opposing forces and embody a worldview of Polar Unity, I hereby change my name to Grey.

December 1976
Boston, Massachusetts

Polar Unity

Spirit is Nothing and Everything.

Spirit, God, or Primordial Awareness, free and liberated from all separateness, is the boundless transcendent ground of Nothingness.

In the primordial void of Nothingness we abide as Spirit, Godself, Whole and One, boundless and beyond time, beyond birth/death, male/female, light/dark, beyond all separateness and opposition.

Infinite Love is co-extensive with the Void, pregnant with pure possibility, birthing All Creation to enact the dramatic experiment of time and the complex orders of multidimensionality inherent in manifestation.

All beings and things, events, and ideas manifest as the evolving expression of the Absolute.

The Evolving Manifest Order of Simultaneously Arising Phenomena is the Creation of Spirit, and awakening to our part in the whole and the wholeness of our part is the Path of Spirit.

Why does Transcendental Spirit manifest from boundless emptiness to the created immanent occurring? Spirit is an Artist, a Creator, and the Manifest Order is the ultimate work of art, an unfinished ongoing masterpiece.

The mind, or consciousness, divides the occurring Kosmos into polarities.

The primary division of Kosmos into self and other, or self and non-self, is necessary to mind, yet is the basis of the delusion of separateness, aloneness, alienation, and suffering.

We mentally cut ourselves off from the Continuum in which we arise.

Love is the glue that binds together the Continuum.

All opposites secretly Love each other.

All beings and things are in Love with each other in the vast Net of Being.

Discovering how we are united through Love energy is the ecstatic mission of the Soul.

Our Soul operates through mind and body to connect or unite us with Infinite Spirit ultimately erasing a sense of separate selfhood.

All opposites are united and simultaneously arise as the play or Creation of Spirit.

The Kosmos is self-creating through the principle of Polar Unity.

The Kosmos is sacred space in which our Being arises.

Our Being is on a journey to recover the source of our Being.

Our Being, our Soul, emerges into the realm of manifestation through Polar Unity.

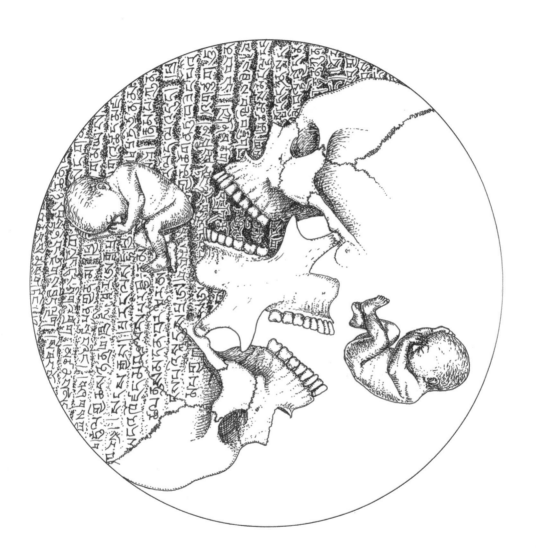

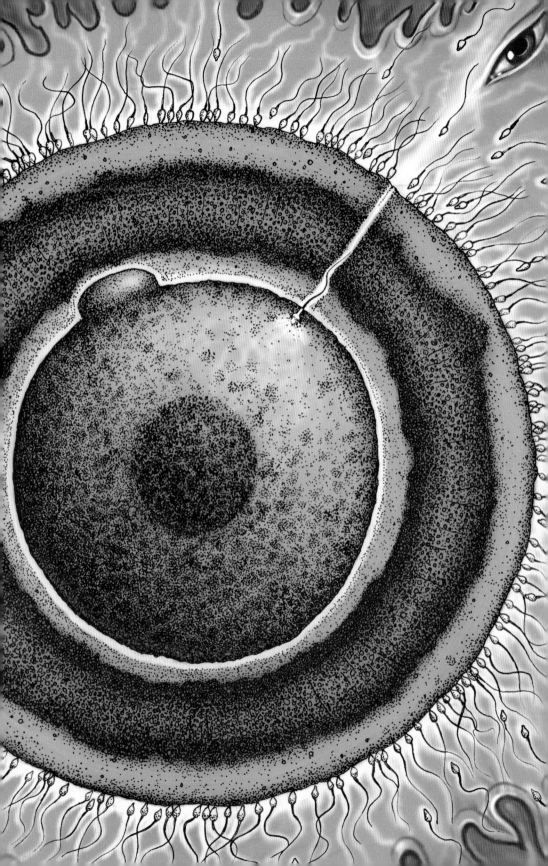

The opposites of mother and father unite in Love.

Sexuality is Sacred. In the Manifest Realm we begin as sex cells from our parents, magnetically, psycho-spiritually attracted to each other.

Sex cells are different from all other cells because sex cells have 23 chromosomes, whereas every other cell has 46 chromosomes.

Our original physical identity is as sex cells—halves of a whole potentiality brought together by the Soul.

Two opposite, separate sex cells must unite. Polarities must unite in order for incarnation, the creative play of Spirit through living manifestation, to occur.

When sperm and ovum unite, a chain reaction of fusion binds the cells into one zygote, the first One, the unique One from which all other cells subdivide to create the unique body.

Love initiates Nothing becoming Everything, and these two are the oscillating polarities of Creation.

Everything manifest can be seen as an aspect of or a polarity of a greater unity.

The Kosmos is one body mind Soul and Spirit manifesting and awakening to the Kosmos as one body mind Soul and Spirit manifesting and awakening.

Creation is an act of Love and beauty, therefore a Spiritual practice aligning us with the Kosmic Order.

All artistic endeavors are the Creative play of Spirit, and a reflection of the collective Soul.

The individual emerges from the collective and evolves the collective through creative expressions of Love and beauty.

Spirit manifests through many orders, many levels, many dimensions.

The subtle worlds of visionary imagination are the intermediate realm between Spirit and Body.

The Mystic accesses the visionary intermediate realm of the divine imagination and witnesses the operation of Soul.

Angels are messengers of Spirit arising in the soul field of visionary imagination.

Angels are part of the many levels of Spirit manifestation.

Angels serve Spirit and are supremely conscious of their subordination to the greater Spiritual Order.
The Infinite One creates all worlds through the angelic hierarchy, and we recognize the Infinite One shining through acts of Kindness, Healing, Friendship, Mercy, Compassion, Generosity, all offerings to the world in grateful service to the care of all beings.

Humans are between the animals and angels.

Higher consciousness and conscience are the gifts urging us to transform, to become more angelic.

Life is a transformative journey if we choose it to be.

Unfortunately, it is most often through tragedy that we awaken to the preciousness of this gift.

When we encounter Death, the end of physical life, we recognize the futility and pettiness of our divided self.

The spell of separation of self and other is broken when our heart breaks and we care for more than our separate self.

We are Sacred Mirrors, opposites reflecting each other, ultimately realizing our unity with the Kosmos, Transcendent and Immanent, united by Infinite Love.

Align with Creative Spirit and let infinite Love and Beauty pour through your actions, healing all violations and uniting all polarities.

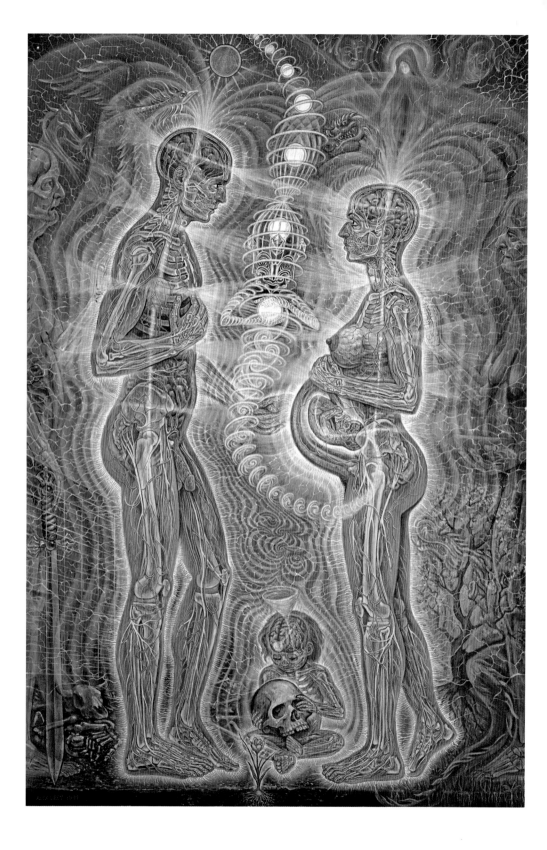

Love Is the Law

A life based on principles affirms values above opinions and recognizes matters of life orienting importance that can be communicated and agreed upon as law. Love is the law governing human affairs. Love is beyond time. The heart's constriction to or full access to Love determines one's view in life.

Love is the Hub of all meaningful values and the fountainhead of creative transformation. Love is not a dogma nor can it be caught and defined by code, yet the virtues of kindness, justice, honesty, forgiveness, peace, charity, reconciliation, healing, trust, joy, beauty, truth, and goodness follow naturally from a heart of pure Love.

Far from the dreamy illusions we project on romance and lust when our vision is clouded by desire, Love is the core of brilliance evidenced in all works of genius and altruism. Love is the organ of transcendent glory and engine of all inspired action.

Wisdom is Love in the judgment seat.

So contemplate and care for this diamond tip at the core of your Soul, because the circle that is spun round as the bounding line of the self is drawn with the compass of conscience and caring rooted in the luminous centerpoint, the diamond tip of Love in your own heart.

Why is it a diamond tip? Love cuts through everything. It is the jewel of life. The power of Love can expand the compass to spin a larger circle of selfhood, embracing one's partner and family, one's community, one's nation, one's world and the boundlessness of the cosmos. Our being is as vast as all space and time when defined from the center of mystery, the diamond-tipped Godself affirming Love is the Law.

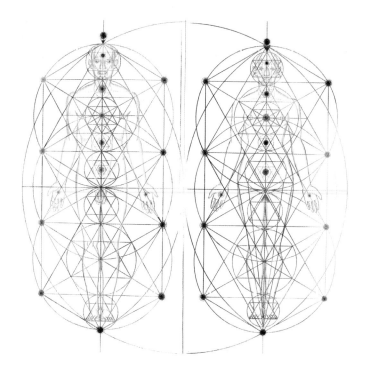

GOLDEN NOTES

Thank you, God, for the Mystic Mushroom.
Release us now from all unnecessary psychic burdens.
May our necessary trials lead to the Soul's Renewal.
Wash our bones and sinews; all our tormented flesh
Purified, bathed in and re-fabricated from
Your incandescent Love Energy.
Please guide artists to channel universal archetypes
That help lead the world to Peace now.

God said:
THE GEOMETRY OF BEAUTY IS WRITTEN IN THE GOLDEN RATIO,
THE SACRED HARMONIC PROPORTIONS EXISTENT IN ALL LIVING THINGS.
PERFECT BEAUTY IS ALIGNED WITH THE COSMIC ORDER.
BE VIGILANT ABOUT YOUR CREATIVITY.
IT TAKES RELENTLESS, UNDISTRACTABLE CONTINUITY OF EFFORT
TO REACH THE TEMPLE OF ART.
BUILDING SACRED SPACE IS AN OUTREACH,
A DEMONSTRATIVE RITE OF MYSTIC STRENGTH.
A TRANSCENDENTAL LIGHTHOUSE, A BEACON OF PURE CONSCIOUSNESS,
A STRANGE ATTRACTOR RADIATING VISIONARY POWER.

CHAPEL-BUILDERS IN THE WORLD
ARE WAY-POINTERS TO THE MAGNIFICENT BEAUTY
OF EVERYONE'S BEING.

TRUE SACRED SPACE IS YOUR LUMINOUS SOUL,
SPHERICAL AND OPALESCENT LIKE THE FULL MOON.

TEMPLE ART IS A LANGUAGE EXPRESSING LOVE
TOWARD THE MYSTERY AND LIVING NATURE.
DON'T DESTROY THE WEB THAT SUSTAINS YOU.

RECOGNIZE THE SACRED GIFT OF LOVE THAT NATURE IS.
WHATEVER THE PATHOLOGIES EMBEDDED IN IT,
YOU ARE SUSTAINED BY IT.
DON'T DESTROY THE WEB THAT SUSTAINS YOU.
THE WEB OF LOVE IS THE GREATEST, RAREST, AND
MOST INFINITE TREASURE IN THE GALAXIES.

GET THE FANTASTIC ODDS OF YOUR CREATION.
YOU ARE LIVING BREATHING MIRACLES OF EVOLUTION.

LOVE IS THE MOST POWERFUL FORCE, ULTIMATELY,
BECAUSE YOUR EXISTENCE IS JUDGED
ON WHETHER YOU HAVE FOUND IT
AND CHERISHED IT IN YOUR LIFETIME.
DID YOU TREAT LOVE IN A HOLY WAY, WITH A RESPECT
YOU ONLY GIVE TO YOUR OWN SOURCE?

THE FACE OF GOD IS EVERY FACE
YOU WILL EVER ENCOUNTER
WHO MADE THESE FACES?
GOD ALONE.

OFFER YOUR TRANSPARENCY TO THE MYSTERY
AS YOUR GIFT TO THE WORLD.

I asked for this perfect day. Thank you, God.
Thank you, God, for hearing me.

God said:
PARENTS LISTEN TO THEIR CHILDREN.
PARENTS ENCOURAGE THEIR CHILDREN
TO UNDERSTAND AND EXPLORE LIFE IN THEIR OWN WAYS.
INITIATIONS CATALYZE THE EVOLUTION OF CONSCIOUSNESS.

FIND A WAY TO NURTURE ALL OF THE ENTHEOGENERATION,
THE GOD AND GODDESS WORSHIPPING FREEDOM LOVERS.
SO THAT THE JUSTICE DEPARTMENTS LEGISLATING RELIGION
REPRESENT THE WAY OF TOLERANCE
AND RESPECT FOR CREATIVE DIVERSITY.

May the Spirit of Justice reside
In the hearts of all those in Power.
And above all, may the Love of God's presence
Outshine every divisiveness.

May we children learn to create together
A more truthful, just, and beautiful world.
May we become more truthful, just, and beautiful people.
Help us to dissolve the rigidity in our character,
To flow with love more fully,
To embrace the Divine Communion,
Soul to Soul, of every being alive.

May all beings know love, wholeness, and sufficiency.
May all beings be healed.
May all affliction be overcome with God's help.
May the infinite Love of God bless Nature and the web of life
With new strategies of healing and recovery,
And allow us to embody resilience and assist and embrace
The eco-meme in our midst.

The Temples in Heaven are made of Kaleidostone,
Interwoven with precious gem and jewel.

From inside the future Temple I see
The seven-ness of Seraphim
Staring up the legs of highly flame-patterned Seraphim,
Realizing they are columns that lead to mirroring, gothic arch angels
Standing on their shoulders.

Seraphim that lick and drink from the Heart of Vision.
All uplifted, infinite interconnected scalloped domes and niches
Formed of cosmic spectral elves
And red gold angelic architecture,
Weaving walls sculpted
With ultramarine glazed ceramic Celtic dragons,
Interlacing flaming golden Islamic Temple scripts,
Framing Moses's two tablets,
Sprouting the most highly branching Trees of Life.
Glimpsing the Empyrean, I see
Mandala domes of interwoven translucency
Hovering dynamos of interdimensional Sacred Geometry.
Stained-glass channel torrents of purification through the soul.
An ascendant flame, the One,
Flanked hexagonally, thus Seven.
Seven Flames, one central, are the angelic architecture
Of Cosmic Spirit, Earth in the heart,
Galaxies spiralling out the funnel of the head.

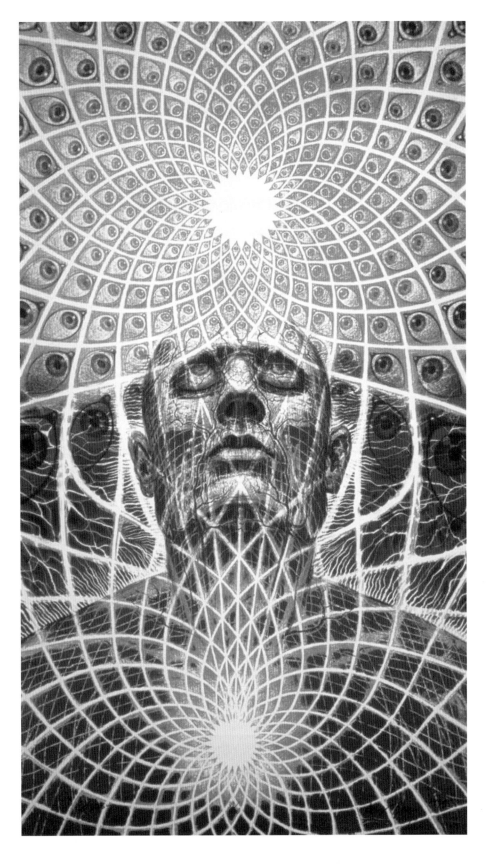

WHAT PRAYER IS

Limited self, gazing upward
From finitude toward the infinite
With shameful lack of realization,
Crying to be filled
With Divine Love and Creative power.
Openhanded pleading for
Showers of blessings
On parched soil of soul.
Confessing all misconduct,
Petty and grave.
Listening at the Abyss
For echoes answering.

Gratefulness, like storm clouds clearing,
Breaks a ray through the grey wall.
"Submit to the future, evolving you.
A fruitful metamorphosis awaits,
A wiser outcome is assured.
Align with it.
Surrender to it."
Across the Void
A second sight
Glints in the Third Eye.
Passion's storms harnessed,
Songs drop on mystic ears
Without formula or guile,
Purely.
Declaring dilations of
Selves to Souls
Searching the Beyond Within
And Without.
All is Good and All is God.

A peace from corestar central
Pervades the praying mind and
Ripples out in actions of
Unrewarded kindness
'Til hindrances bind and
Constrict soul subtly
To smoldering glint hid away.
A spirallic yearning seizes
Limited self gazing upward.

Spiritual Guidance System

Dear God,
Thank you for all the senses
Given through my body and mind.
My sense of smell, touch, taste, hearing, vision.
Through these channels I know the world.
I orient myself in space,
I am warned of danger,
I am drawn to nourishment,
I delight in Your world.

By the gifts of the saints I know
There are senses of the Soul.
Clairvoyants sense a world unknown.
Mystics see Your face, God.
Allow my Spiritual Guidance System
To open and wisely use
The senses of the Soul
To better serve the world
So that obedience to Your Plan
May be more certain.

When you see that
I am ready
May I receive
These gifts of the spirit,
Senses to perceive
The Visionary worlds
Of Your Divine Imagination.

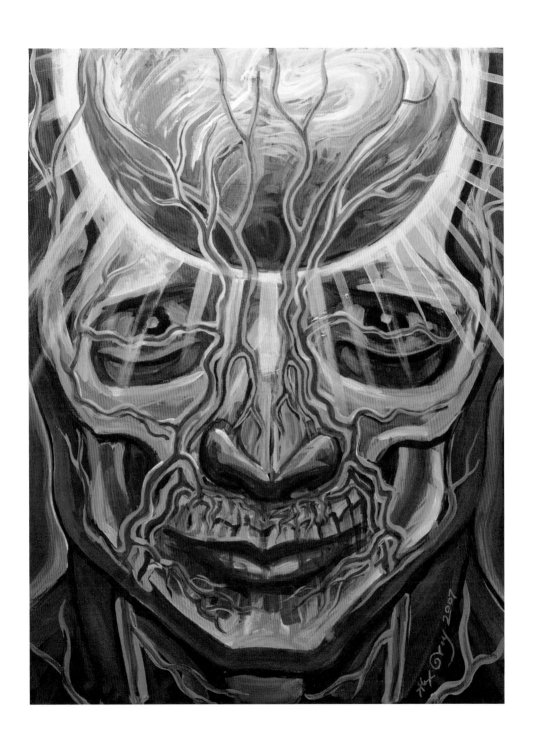

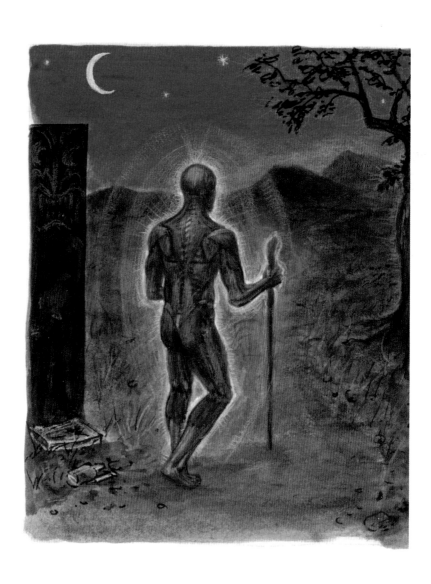

Nature of Mind

Panel One

A wanderer from the West
Did go upon an unclear path.
As bone and flesh, alone they went
Through dark unholiness.

A wonder, "Can I find myself?"
Brought clearing and a voice,
"Nobly Born, seek spiritual dawn.
The path is open, it's your choice."

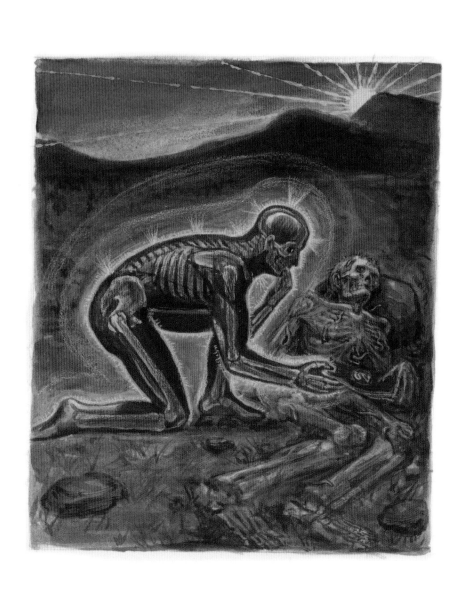

Along the path, Death,
Mirror of future collapse.
Animal powers surround and protect
The teacher as a Corpse.

The teaching is taken.
The Sun emerges.
Book of the Dead,
Direct me, ressurect me.

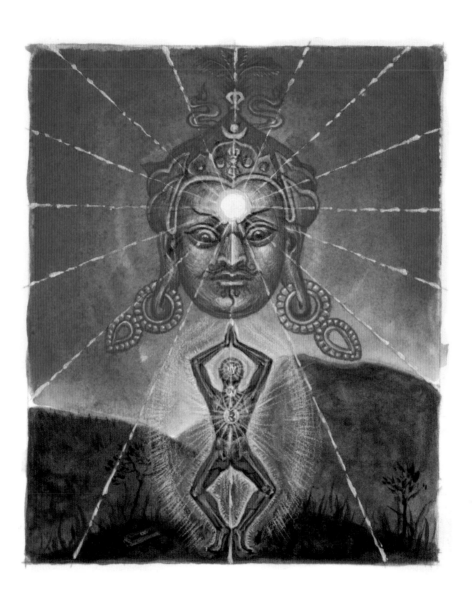

PANEL THREE

Climbing the mountain, slipping and
Falling, struggling to upper reaches,
The path of practice can be long
And arduous as it teaches.

Holy Book ignites a Vision,
Seeker becomes Seer.
Karmic preparation allows
The face of the Guru to appear.

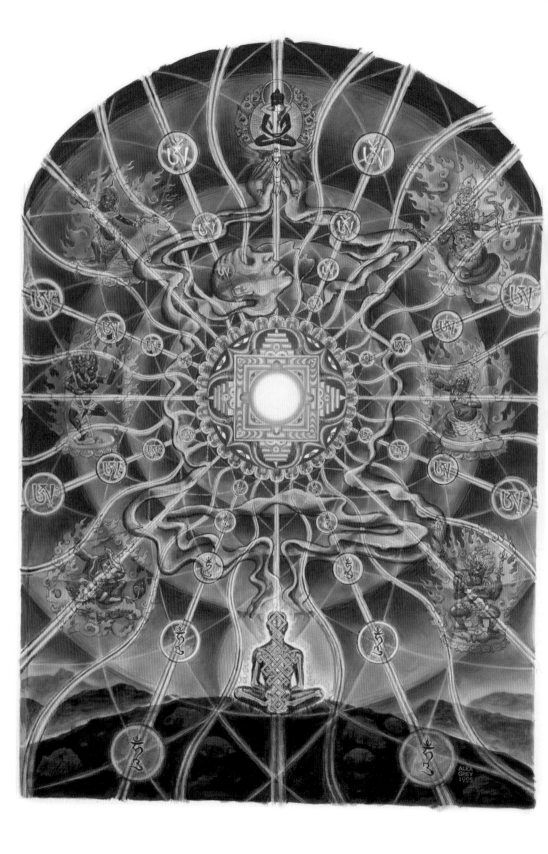

PANEL FOUR

The three worlds are united,
From lesser to greater Being.
Visions spontaneously liberate
As vastness nakedly seeing.

Awareness supreme and central,
Voidness radiant and clear.
Inner sun, outer sun, non-dual,
In the heart no desire or fear.

Guardians cut loose my empty husk,
A human skin pelt of turquoise sky.
Reveal the mandala of Great Perfection,
A resplendent Buddha, I.

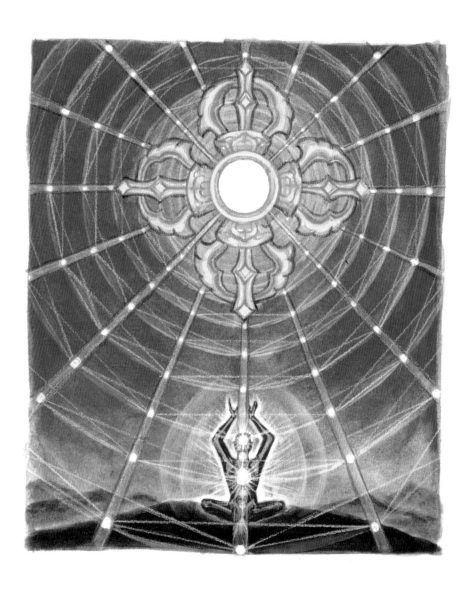

PANEL FIVE

The essential Vajra teaching,
Condensed in a rainbow sun,
Transmits a fractal message,
"Wake up, Everyone!"

The inspired yogi reaches
For universal truth's jewel,
Encoded in a heart drop
Or a crystalline molecule.

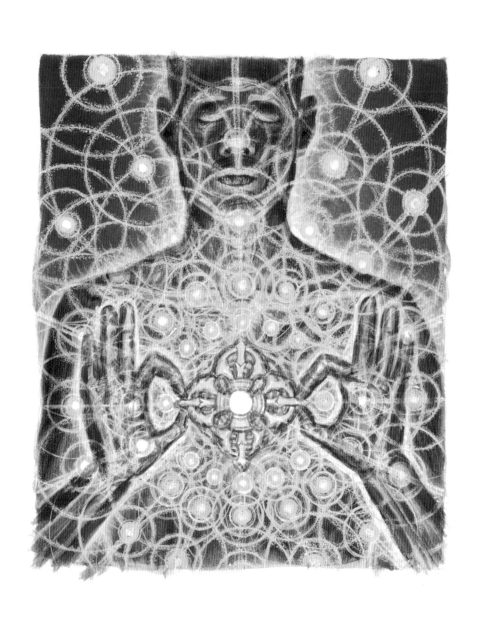

Panel Six

Diamond scepter Vajra,
Pure of stain or ill,
Now has found its heart home
As the engine of creative will.

Empowered to penetrate others,
With primordial waves of bliss,
Shimmering resonant lovewebs
Spread out to boundlessness.

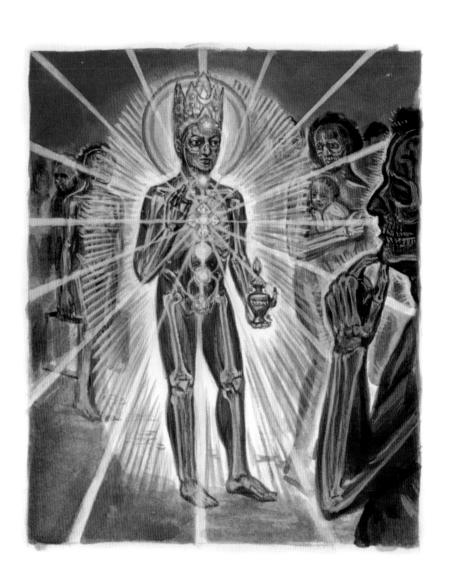

PANEL SEVEN

All beings and things included
In the Bodhisattva's vow.
Therefore a return to the world
But in touch with the timeless now.

An elixir of wisdom and compassion
Does Maitreya bring to all.
Everyone is a future Buddha.
Listen deep for the inner call.

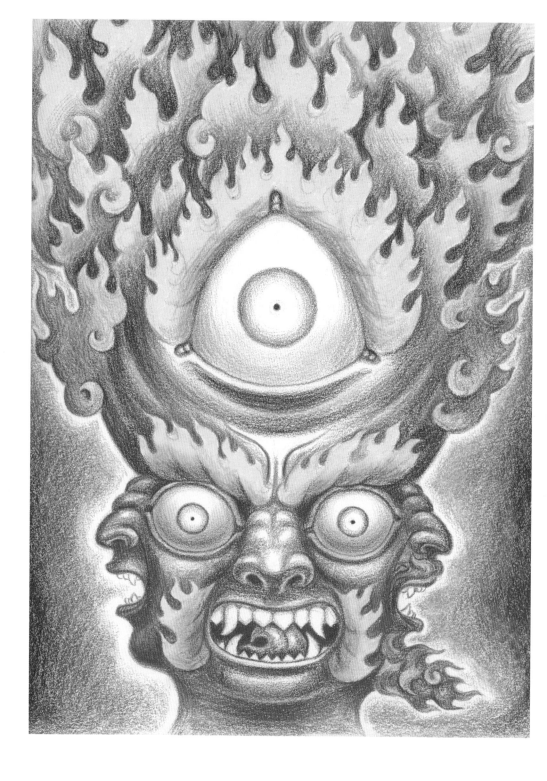

Forgive Me, Creator

Source of all art,
Forgive my shirking
Your gifts.
I have received your visions and songs,
Been inspired by your
Angelic emissaries and
Carried aloft by your grace
And yet have not fulfilled the mission
You've given me.
I've operated below my potential.
I've been distracted by unworthy matters,
Wasted precious time.
I promise to work harder
And devote my life
To sharing creations that cause minds
To catch fire with
Your gifts.

Guardian of the Endless Smile

Praise Laughter,
From the slightly upturned mouth,
To the painful sideache.
Gasping for breath,
May we hear the cosmic joke
And see the ridiculousness
Of life and the world.
When the tragic overwhelms,
Infect us with your
Preposterous happiness.

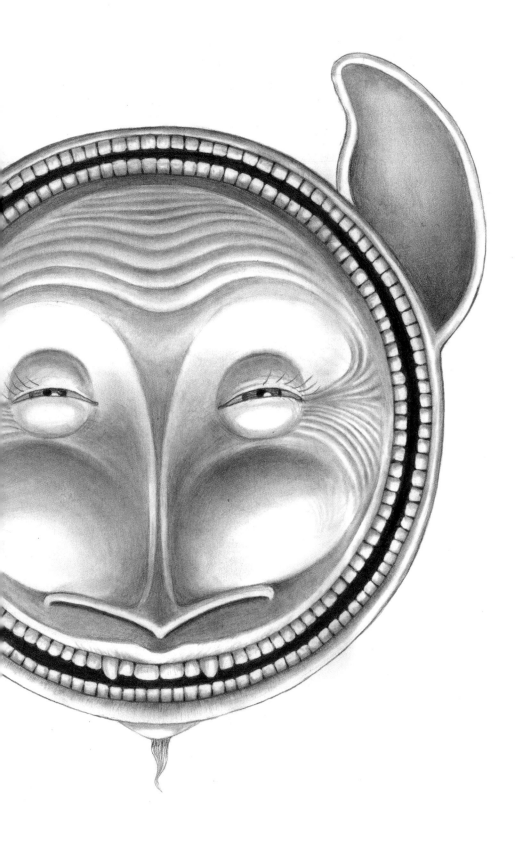

Guardian of Infinite Vision

Praise the All-Seeing Being
With Omniscient eyes
At the Gateless Gate,
Protector of BuddhaMind
From uncommitted seekers and
Unsurrendered onlookers.
For those insurgents
Wishing to see
The fabric of reality
Weaving through vast space,
Penetrating fathomless depths
And heights,
All colors and patterns,
Be ready to die to your small self,
Causing all forms of suffering.
Groan in the ocean of injustice and death.
Hell hath no fury like BuddhaMind.
Nothing is hidden.
All is revealed.
Hearts crack open, unleashing
Dams of unconditional compassion,
Waves of Birth and ecstatic creative joy.
Wisdom, love, and healing
Are also infinite.

MASTER OF CONFUSION

Observing and
Becoming the tangle,
Digesting reality
To undo the knot.

AT RISK

Life is always lived at risk.
We may grow complacent
And not realize it.
We may not smell the fresh sweat
Of anxiety or excitement,
But what are we breathing for?
Touch the nerve of passion
And live for greatness.
Fear of failure stops many,
But Death stops everyone.
So love without restraint,
Create the New,
Follow the courage of your highest dream.
Fate favors your daring.
Risk surrendering to Love,
And gain your Soul.

The Sool (A Foolish Soul)

For my daughter, Zena, age 7
1995

The Happy

If thou wilt be happy forever and a day,
Thou shalt listen to the voice of the Sool and obey.

The Heart Garden

In order to hear the song of the Sool,
Thou shalt cultivate a garden where silence can rule.

Divine Receptivity

The Sool sows seeds in a well-prepared heart,
Each seed is a mystery school of sacred art.

The Crows

Guard thee against the mocking crow,
That eats a Sool seed before it can grow.

Flowers of Inner Sense

From silent soil sprouts the flowers
Of senses whose roots are heavenly powers.

The Bugs

Watch for bugs who are mean and cruel,
For they love to devour a flower of Sool.

Deep Listening

To the open heart garden in full fruition,
The Sool sings love songs of brave intuition.

Song of the Sool

"Blessed art thou who take time to listen.
Thy inner sense follows a fateful mission.

Feel the beautiful truth of the Good.
Infinity is thy neighborhood.

When creative spirits keep wisdom alive,
Angels of love and healing arrive."

Having heard and heeded the voice of the Sool,
Thou liveth the life of an inspired fool.

For some, thou become an object of derision,
For others with heartseeds, a symbol of Vision.

Happy though flung in the dung heap of here,
The Sool sings through a heart-eyed Seer.

A patient heart-gardener is sure to harvest
Life's bounty of good works and happiness.

We are seeds sown by God, the garden is our school.
Art is God's fruit tree, the Song of the Sool.

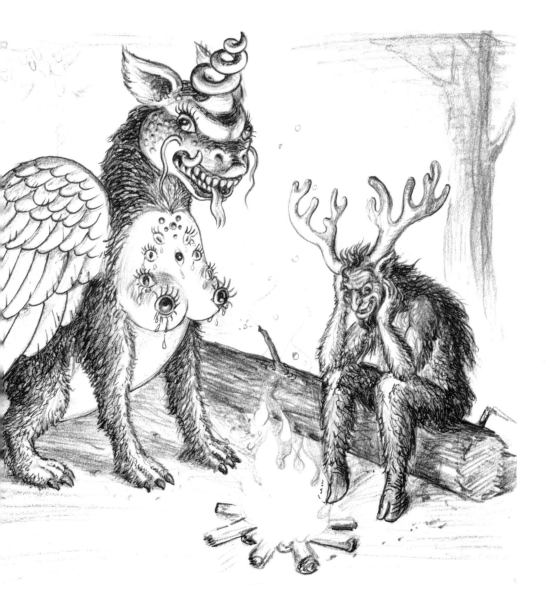

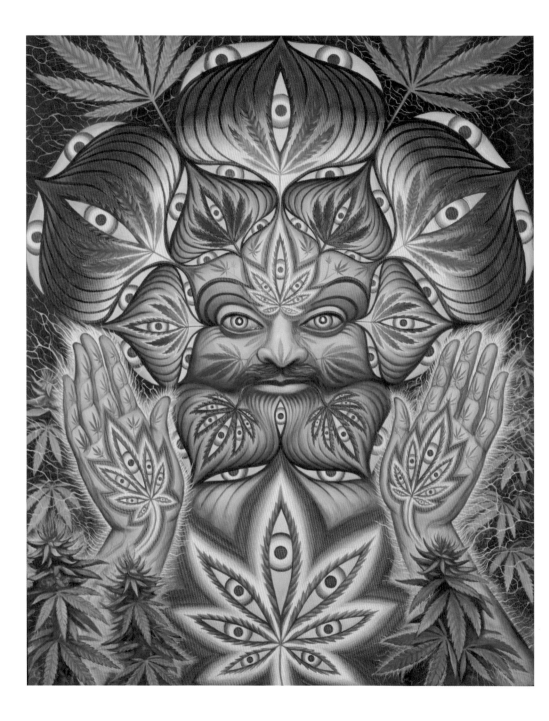

Seven Lights of Cannabis Wisdom

1. The Light of Utility

Cannabis is nature's most useful plant, providing hemp fibers
for clothing, rope, hemp paper, hemp oil, hemp plastics
stronger than steel.

2. The Light of Sexuality

The increased sensitivity and aphrodisiacal qualities of cannabis
inebriation are undeniable.

3. The Light of Health

The numerous medical applications of cannabis for healing
and hemp powder as a complete food are a boon for the body.

4. The Light of Love

Cannabis opens the heart and sensitizes us to others.

5. The Light of Poetry

Cannabis allows the flowing tongues of bards contact with
new modes of knowing and speaking.

6. The Light of Vision

Opening of the third eye allows the artist in everyone access
to the Divine Imagination.

7. The Light of God

Ganja smoking Babas, Rastafari, and many others regard
cannabis as a sacrament opening us to the highest creative
source, allowing us to realize we are the Light.

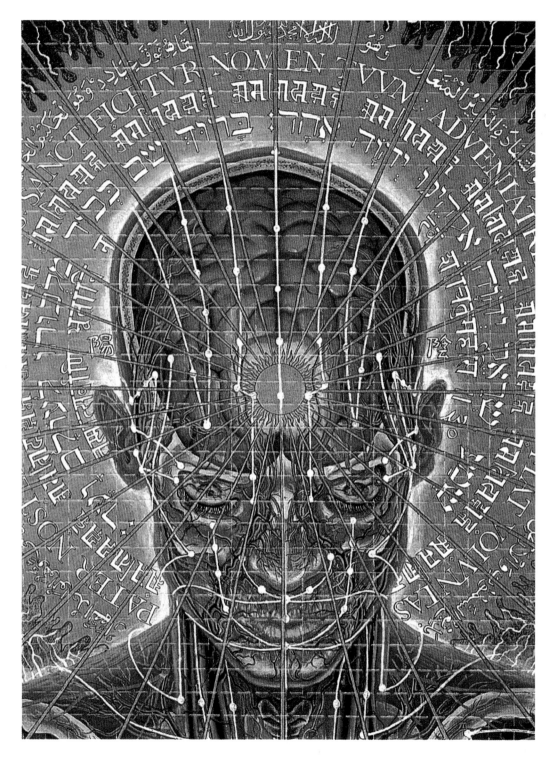

LET'S SEE DEEPLY

I see the blotter in my hand
And know that it's a key
That unlocks doors
To vision realms and love's infinity,
And yet a terror grips my guts
Before I swallow LSD.

For though I willingly submit
To unknown region's cry,
There is a helpless fearfulness
When the ego is about to die.
God grant your blessing on this trip
Into the unforeseen.
For the benefit of one and all,
May the soul become perceptible.

I swallow the electric host.
My body's subtle field notes
An alchemystical change of lenses.
One tiny drop makes me drop my defenses
And eventually relax into
Flowing streams of waking dreams.
Parades of scintillating creatures,
Multiplying limbs and features.
Liquid Mind, your absolute oddness
Is my lodging of constant surprise.
A peacock's tail fans
The furnace of my soul
With a brocade of jewels and holy fools
Morphing across my cartoon screen.
What angels shuttle
Across my synaptic clefts?
The spirit-molecules fly in formation,
Unleashing Divine Imagination.

For those who journey,
Those who madly risk meaning,
A Sphinx's roaring laugh
At the condition of our little minds.
So transparent now, so demeaning,
Reason erects walls like skin
That make me think we end and begin

Inside a constricted skin-bag self.
But now, that self-image is dying.
It's like a corpse there lying.
When our self-conception dissolves
Into the entire universe,
We offer no resistance to being
Everything at once.

I'm an ecstatic seer-nomad now,
Traversing cultures in a single glimpse.
Torrents and waves of imagery lap fractally
At the drunken boat of my awareness
Slicing through brain waves.
The winds of karma incline my sails
Toward the Buddha in my neurons.
Religions are neurons in the mind of God.
And God's eye sees beyond my fears
And sees me through the sea of tears,
Past the ocean of rotting corpses,
Past frightening whirlpools of doubt and derision,
Up steep mountains of Holy Vision.

And from the heights what can I see?
Does God exist?
The answer's yes,
God's here in me and you and you and Everything.
I cannot see God's end above,
But God's beginning is here in love.
Foundation and final station of our quest,
The grail of love is Holiness.

The light of love is an opalescent mandala,
An electric ocean of illuminated milk
Flowing from the grail,
Washing through me, purifying negativities,
Saturating every cell with living love,
Surrounding every being with healing light.

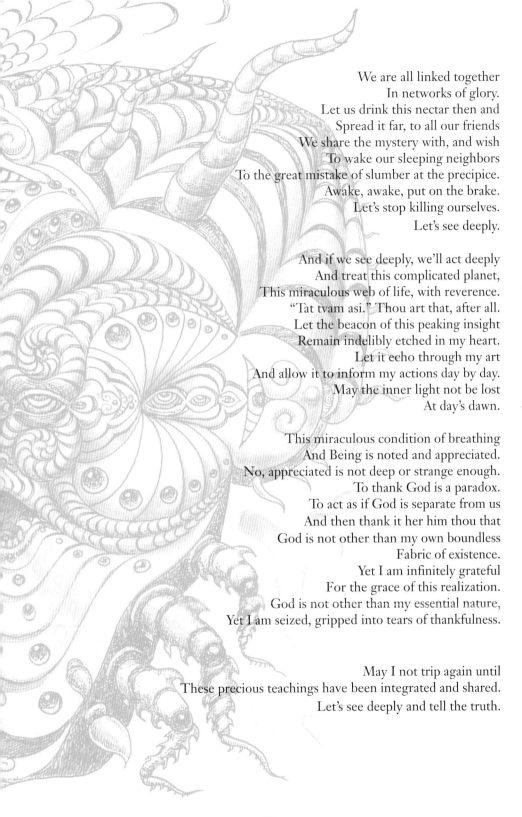

We are all linked together
In networks of glory.
Let us drink this nectar then and
Spread it far, to all our friends
We share the mystery with, and wish
To wake our sleeping neighbors
To the great mistake of slumber at the precipice.
Awake, awake, put on the brake.
Let's stop killing ourselves.
Let's see deeply.

And if we see deeply, we'll act deeply
And treat this complicated planet,
This miraculous web of life, with reverence.
"Tat tvam asi." Thou art that, after all.
Let the beacon of this peaking insight
Remain indelibly etched in my heart.
Let it echo through my art
And allow it to inform my actions day by day.
May the inner light not be lost
At day's dawn.

This miraculous condition of breathing
And Being is noted and appreciated.
No, appreciated is not deep or strange enough.
To thank God is a paradox.
To act as if God is separate from us
And then thank it her him thou that
God is not other than my own boundless
Fabric of existence.
Yet I am infinitely grateful
For the grace of this realization.
God is not other than my essential nature,
Yet I am seized, gripped into tears of thankfulness.

May I not trip again until
These precious teachings have been integrated and shared.
Let's see deeply and tell the truth.

The Love Rites of Kali and Shiva

As Shiva sits in meditation
On his Mountain
The Goddess fills his heart
His body rests in the formless
While contemplating her

Her Yantric Yoni her black hole
The Miraculous Gates of Creation
Her kosmic Ass the Roundness of the Earth
Perfect—Beautiful
Seducing the formless into form

The Game of Creation and Destruction
The Game of Illusion and Enlightenment
We hide our essence in matter
Mother matter mate-her
In Rites of Love

In every atom the electrons spin
In orbit around a center
The Atomic Mandalasphere of
Attraction and Repulsion is repeated
Holographically throughout the kosmos

Of all the forces
The strong the weak, the gravitational
The electromagnetic
The strangest strongest force of all
Is the force of Love

Beyond all form
Love is the kosmic adhesive
Binding the All
And playing out its Rites
In every Dimension

The unified field of Love
Is Shiva's passionate worship
Of Kali's magic Yoni
And Her rounded Bottom
He caresses it in his mind

His Lingham multiplies
The erect and hydra-like expansion
Of the Tip of awareness
The advancing engorgement
The heads see in all directions

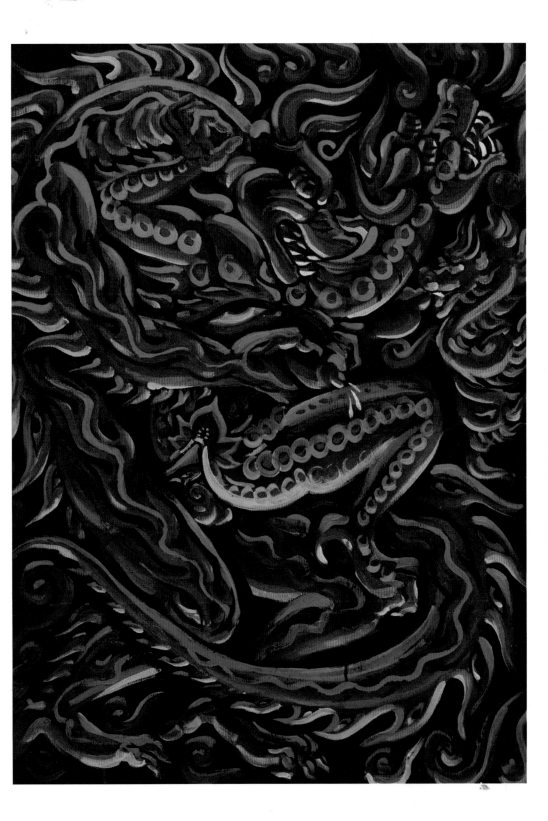

Searching out the beloved
Now is the stag bounding to the doe.
Now is the bull elephant
with his erect penis the size of a man
Advancing to her

Now is the seven-headed Stallion
Pursuing the seven-headed Mare
The birds the tigers the lions
Ponds frogs swims mates
The entire world copulates

In harmony with the Love dance of Shiva
Ecstatic waves of bliss
Crash into the beach
In time with the pranic pulsing throb
Through Shiva's kosmic nob

Their eyes meet
Connecting
Attracting consenting
Melting in concert
A common fluid flows from the eyes

A stream of passionate fire
Braiding infinitely
Radiantly
Lassooing the lovers
Closer

The arms of the spiral galaxies
Are the spiralic pursuit
Of lingham and yoni
Turning turning
Entering burning

Each star the ignition
Of love in the minds of Kali and Shiva
Through Kali's gates of Love
The entire universe has been born
Each star a cell in the universal child

Beautiful spawn
Of the dalliance of Kali and Shiva
Invisible forces
They are moving
All that is visible

The dance of their love moves us
Back and forth—
Toward and away from each other
Again it is time
For the rites to begin

The arousal of Shiva
Is drawn toward the mysterious odor
From the gate of Kali's swollen flower
Shiva is a bee buzzing toward
The pollen of Kali's cosmic egg

Inexorably drawn toward her
They meet
She halts his advances
With one hand touching his heart
As another hand grabs his organ of desire

She slithers her wet and snakey tongue
Around his throbbing mountain.
He shakes a God-quake of Love bliss.
As she blows
Wet hurricanes are born

She plays him like a flute
Truly this is Krishna's love song
Which drove the Gopi girls wild
She engulfs his infinite cockheads
With her infinite mouths

She controls his power
He cannot move
He is frozen in ecstasy
She could bite clean through
Or unleash his ocean

He holds back
His nuclear explosion of semen
Savoring her every tongue caress
And erotic bite
She stops

He violently thrashes her ass and tits
Then plunges his tongue into her yoni
Her yummy yoni
All the earth is fed
As he laps her pussy

We eat her every day
Are only hungry
For the fruit of her
We eat her and drink her
Are drunk with her juice

Kali's vagina
Is our every, our only food
She feeds us amply
Her breasts are grapes
On pears on melons

Her loins are all succulent meats
Her lips are ripe vegetables
Spices and herbs
She rolls her hair
And we smoke it

As Shiva eats her body
She turns sour
She starts to rot
She turns black
And smelly foul and disgusting

Shiva loves her angrily
Nasty Kali
Wicked Kali
Deathly Kali
You deserve a spanking

His hands strike her overripe ass
Shaking her skin
She loves his anger
It harms her not
Oooh Daddy, Kali is a bad girl

You have to punish me
For causing everything
That is born and fucks
To die
Bad, bad Kali! Ha! Ha! Ha!

He grabs her by the ass
And stabs his multi-prick
In her infini-cunt
She heats and screams
She drips and moans

Shiva's trident of passion
His Love weapon
Stabs and rips
Burns out of control
His third eye rolls

His love screams "Aum"
As he cums in slow motion
Whole species evolve
Are born and die
Through a billion star systems

Shiva's semen
Is the ocean of life
Flowing expulsively
Explosively through all life
Morphing over millions of years

1·17·01

Shiva cums for the infinith Kalpa
Draining all life from his flacid frame
His skin turns ashen
His joints stiffen . . . He dies

He exits his metaphysical form
Melting into boundless emptiness
Exhausted in Sunyata

Kali summons
His dead rigor mortis lingham to rise
Pumping away she shrieks her
Victorious ferocious Orgasm
Echoing through the universe
Passionate horror inexplicable

She uses her sword
And cuts off his head
And cuts off his cock
And hacks him to bits
Flinging him to kingdom cum

Scintillating swarms of Garuda birds
Carry his delicious body
Through interdimensional space
The destroyer is again destroyed
By creative ecstasy in an endless round

Her black hole
Collapses the entire universe
All Both become One, in pregnant void
As Shiva sits in meditation on his mountain.

ART IS AN ENZYME

Art can be a powerful transformative agent in our culture,
But most art squanders this possibility
By being completely forgettable.

Artist, what are you saying?
What worldview is sluicing through your work?

Art is an enzyme in the cultural body metabolism.
Icons can dilate or constrict the consciousness of the people.
Any good communist knows this.
You can be imprisoned in China
For having a picture of the Dalai Lama.
Icons of Spiritual Liberation transcend and therefore
Challenge iron-headed Authority.
The sphinx lost its nose to that truth.
An entire Buddha mountain was blown up by the Taliban,
To that truth.

There is no liberation offered in corporate advertising,
Only $alvation through consumption.
No hope for the poor.
Worldviews are transmissable through imagery.
A little imagery of murder, torture, and violence
Can catalyze a peace movement.
A lot of imagery of murder, torture, and violence
Contracts our life force.
We are diminished, desensitized,
Drowned in blood.

When art embodies an awareness
Of multidimensional vastness,
Transcending time and space,
Cosmic oneness, ecstatic joy, peace, and love,
Awe-inspiring sacredness, all polarities united,
Then transformative art can unclog the arteries
In the collective meme-stream,
Quickening the cultural body toward
Universal Humanity.

THEOSIS

Art can transform the way we see ourselves and the world.
Sacred art has always depended on this possibility.
Theosis means coming closer to God by contemplation of icons.
New ways of seeing lead to new ways of being.
When your being is transformed,
The world occuring to you transforms.

A great work of art, once seen, is unforgettable.
We encounter an art object and contemplate it.
It remains as a trace in our memory.
Our encounter may have lasted a minute or an hour,
But the artwork is now alive in our minds
Doing it's subtle business.
Art can rewire our brains, suggesting a new reality.

Contemplation of a Buddha or Christ
Implants the possibility of our own enlightenment.
Icons of a United World, a Sacred Planet
Are essential now, to implant
The possibility of saving our collective lives,
Reverencing our Mother Nature Goddesself,
The One WorldSpirit of all plants and creatures.

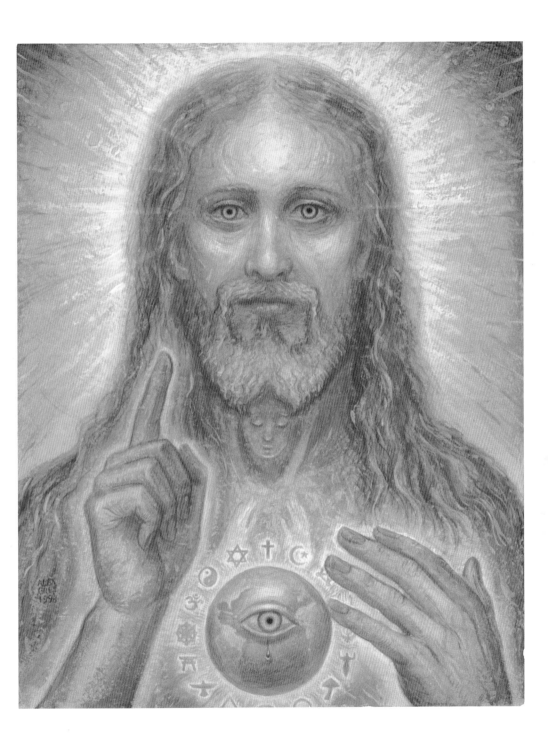

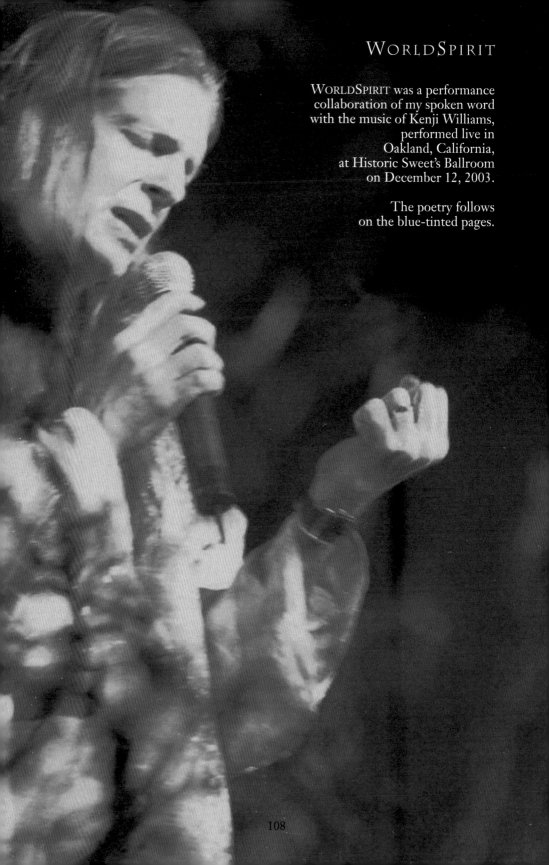

WORLDSPIRIT

WORLDSPIRIT was a performance
collaboration of my spoken word
with the music of Kenji Williams,
performed live in
Oakland, California,
at Historic Sweet's Ballroom
on December 12, 2003.

The poetry follows
on the blue-tinted pages.

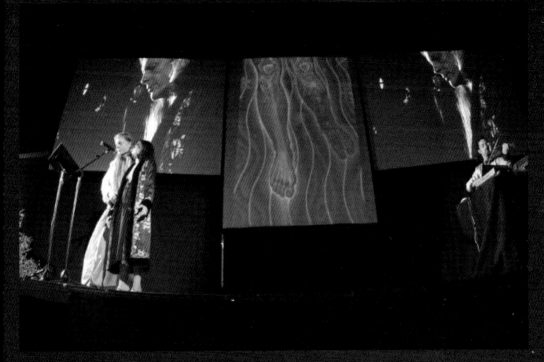

Allyson joined me on stage to recite the WORLDSPIRIT INVOCÅTION accompanied by Kenji on the electric violin.

The audience joins in meditation during the WORLDSPIRIT INVOCÅTION.

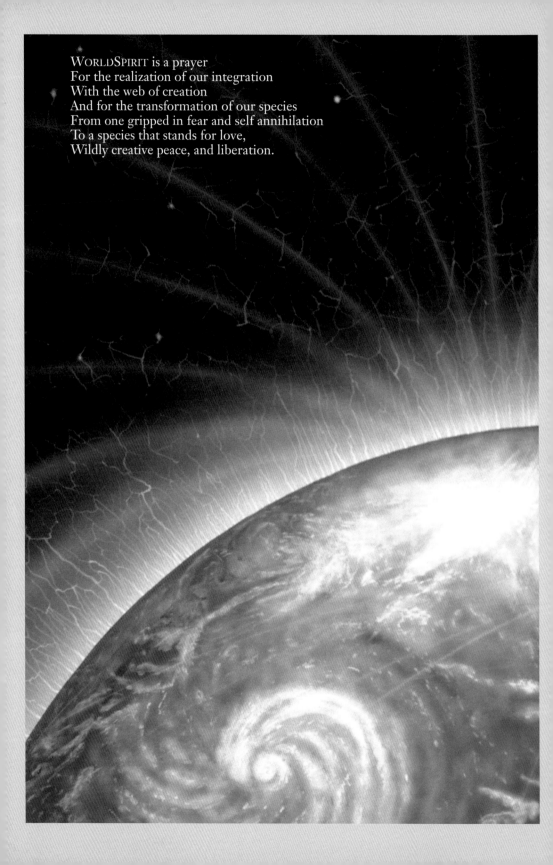

WORLDSPIRIT is a prayer
For the realization of our integration
With the web of creation
And for the transformation of our species
From one gripped in fear and self annihilation
To a species that stands for love,
Wildly creative peace, and liberation.

Art can be worship and service.
The incandescent core of our soul.
A glowing God's eye,
Infinitely aware of the beauty of creation,
Is interlocked with a network of souls,
Part of one vast group soul.
The group soul of art beyond time
Comes into time
By projecting music and symbols
Into the imagination.
God's radiant grace fills the heart and mind
With these gifts.
The artist honors the gifts of sound and vision
By weaving them into works of art
And sharing them with the community.
The community uses them as wings
To soar to the same shining vistas and beyond.

Translucent wings teem with eyes of flame
On the mighty cherub of art.
Arabesques of fractal cherub wings enfold
And uplift the world.
The loom of creation is anointed
With fresh spirit and blood.
Phoenix-like, the soul of art,
Resurrects from the ashes of isms.
Transfusions from living primordial traditions
Empower the artist,
Take them to the heights and depths
Necessary to find the medicine of the moment,
A new image and song of the Infinite One,
God of Creation
Manifesting effulgently,
Multidimensionally,
With the same empty fullness
That Buddha knew
And the same compassionate healing
That Jesus spread.
Krishna plays his flute,
The Goddess dances,
And the entire tree of life vibrates
With the power of love.
A mosaic and tile-maker inspired by Rumi
Finds infinite patterns of connectivity
In the garden of spiritual interplay
As the WORLDSPIRIT awaits its portrait.

LAMENTATIONS

From Under
A Spell of Terror
Spilled illness and Rage
Uncontained
Furious As Hell
Spurious Oil Well
Rot in the Heart
A Sickly Smell
Leaks through Lies
And tells the truth
That rings the Bell
That tolls for the U.S.
Us.

America
You've sold your Soul
For a little Capital

Fiends of death
Speaking with Apocalips
And mi$$ile throats
And Iron Lungs
And crooked tongues

CorporationNation
Killing truth
Replacing goodness with greed
Sacrificing beauty
As minds and planet are polluted

Why must we so
Unfulfill our promise
How dare we stand
For absence of freedom
Freedom is a real responsibility
But America
We have sold our Soul
For a little capital

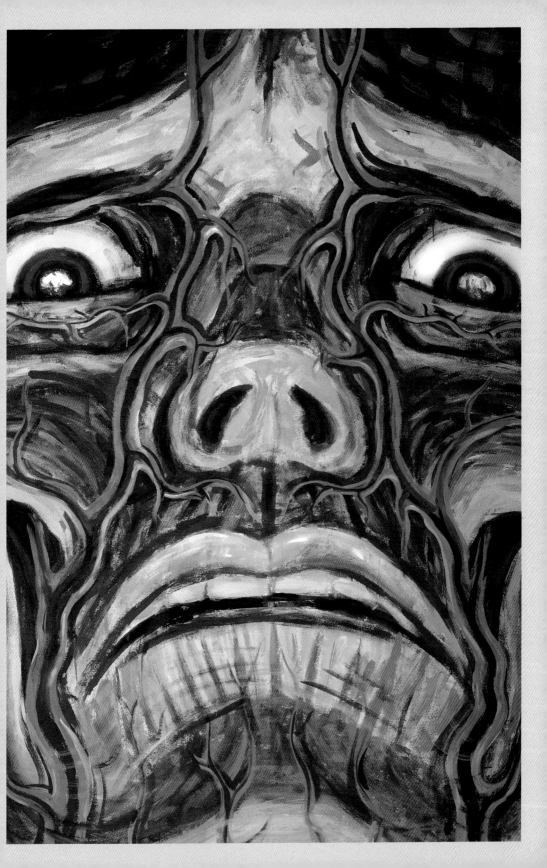

Without reliance
On the Council of Liberation
We cannot rebirth a Nation
We are a plague
And Lamentation

Malignant scourge
Of viral hucksterism
Poisons little birds
And little fish
Two upon your plate
A consumption-like disease
Spreads like wild malls
Across your Gaian skin
Turning soil into
Asphalt and concretized
Misconceptions of Nature and Humanity

America
Do you want to be rich
Look through the lens
Of mystic truth
And see your wealth
Your infinite wellth
A holy healing people
Empowered with a vision for humanity

Democracy is possible
We can work together
When we respect each other
And serve
And inspire
And appreciate
And forgive
And consider each other
As precious as our Mother
Grieve Now
For all the Nations
Of Mothers and others
We have slain
We are a stain
And have sold our Soul
For a little capital

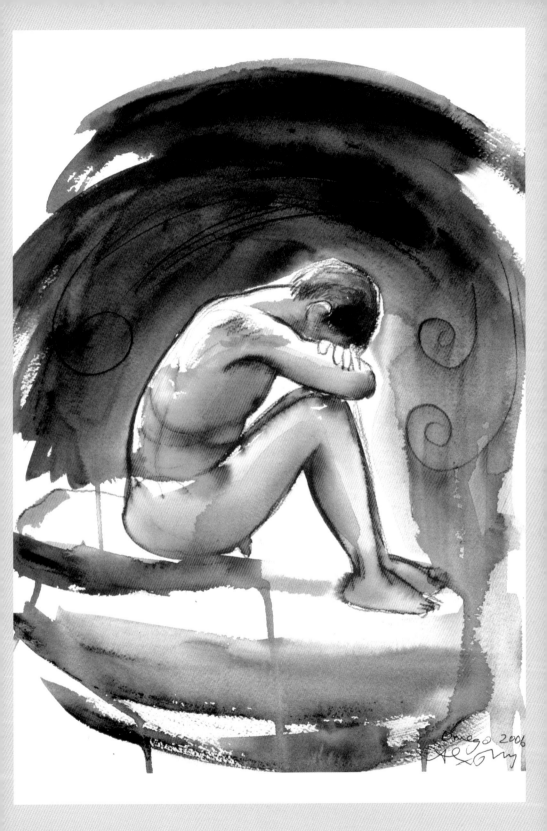

Restoration of our Nation
Is not an Idler's dream
But the fulfillment
Of a contract with God
Let us be one
With all nations under God
Indivisible
For God cannot be contained
Or limited or stained
God is indivisibly one
With all of nature and life
Let us come into the
Center of reality
Where the light
Of spirit shines
In every heart even under
Megatons of malice
And our own weapons
Of self-destruction
And mass-distration

Redeem your soul
As soon as possible
By leading the world
In generosity and responsibility
For the great web
Of flesh and spirit
Wake to your mistake
Resurrect your soul
My soil
Defend our family planet
For the collective good
Respect the youth
Speak the truth
Face your demon America
Transcend CorporatioNation
And be one with creation
Wake from your nightmare
And become the dream of WORLDSPIRIT.

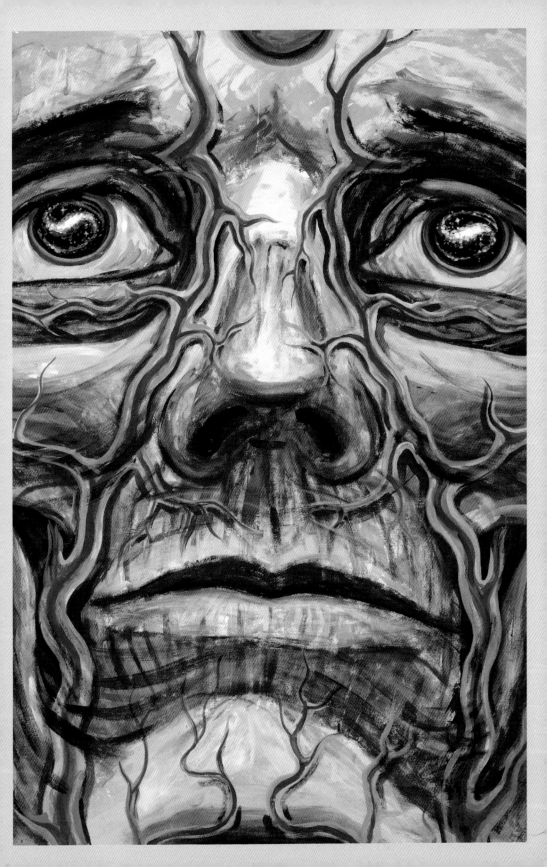

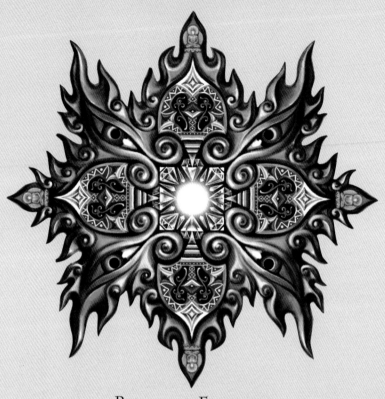

BUDDHA EMBRYO

Bardo Prayer

"When I see my future parents in Union
May I see the love rites of Primordial Buddhas.

Choosing my birthplace for the good of others,
May I receive a precious human body.

May I not follow all my evil karma,
But follow and increase what merit I have.

Wherever I am born, at that very place,
May I meet the highest truth face to face.

Wherever I am born, may that land be blessed
So that all beings may be happy."

In the beginning was the unborn, undying,
Indestructible Spirit drop,
The luminous Buddhamind
Evolving through infinite lifetimes in infinite places,

A DNA hologram of spirit and matter,
Male and female, life and death.

I have been watching my parents to be,
And was attracted by the energies
They radiate during copulation.
And I realize this is my original face.
Dad's lingham, Mom's yoni,
Divine portals of primordial ooze,
Channeling my ecstatic essence
Of bodily selfhood.

I enter my father's top chakra
While he's making love with my mother,
And move down through his psychic energy spinal column
And catalyze the group soul of the sperm.
Then comes the hormone cannon
Firing great gift seedfish into mom's socket.
Beginning their intrepid six hour journey,
Crawling and wiggling through the cervix
And the dark canyons of the uterine folds,
Sperm, like a battalion of soldiers
Is magnetized toward the ovaries.

One corps goes down a dead-end fallopian,
The other team fights its way to the Princess,
Newly hatched from her ovarian womb, tender and pink.
Does his special sperm
Break through the walls of the ovum,
Or does her egg choose and allow in the One?
Our collective karma and consciousness does the choosing.
I am her (23xx), I am him (23xx), I am (46xx).
I survive the war of becoming,
Surrounded by millions of dead brothers.

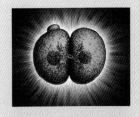

As a Buddha Zygote,
I begin the alchemy of embryology by
Inserting my prima materia
Into the uterine alembic.
The ovum is in the oven.
Mom is the soul furnace.
My cells pulsating, subdividing,
Expanding into a blastocystic ball parasite
Embedded on the wall of the uterus,
Sucking blood through my roots

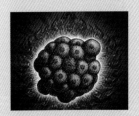

Twenty-four hours a day.

And now for my biggest trick,
Requiring precision timing and a leap of faith.
I shall enfold myself,

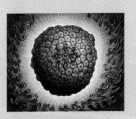

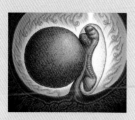

A topological wunderkind.
Gastrulation is perfect this time around.
God is at the wheel, steering through the Deva's eyes,
Driving my cell clusters around my morphogenetic field.
Those aren't gill slits. Those are my ears!
My genomes are humming.
There is a veritable Niagara of blood
Coursing through my umbilicus.
The sounds are a deafening roar

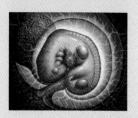

Inside the meat pump of the body.
I hear all the digestion,
The stomach grumbles, the farts,
And the strange familiar echoes of outside life.
Muffled underwater sounds
Through the amniotic fluid.

The divine spirit-atom is my heart center,
Radiant fuel of my organic jewel.
And I witness the magical loom of my cellular body
Being stitched together from the inside.

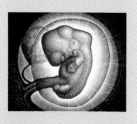

Protein prayers written in genetic code.
Bulges become limb buds, buds extend into limbs,
The details refine in my pulsating skin blanket,
Fingernails, fingerprints.
Cartilage becomes bone.
No longer a transparent fish, I become a monkey.
Ontogeny recapitulates Phylogeny in the Sacrogeny.

I have chosen to incarnate, again.
A Bodhisattva.
Although I've dwelt
In the realms of bliss and pure light,

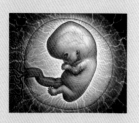

What fun is there in Nirvana
When other beings are suffering?
So I'll take on a human body
And dedicate my actions for the benefit of all beings.

Over many months,
My millions of cells have outgrown
The warm peace ocean of my mother's body.
And in this perfect moment the heavens have aligned
To initiate my passage.

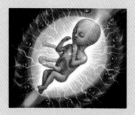

Suddenly, all that was soothing
Has become unbearably painful.
The contractions begin to crush my body.
My God, why have you forsaken me?

Life is suffering,
The first noble truth.
I cannot escape this Birth/Death prison.
I'm trapped and doomed inside of her suffocating womb.
Attachment is the cause of suffering,
Second noble truth.
The flesh bag rips open,
The ocean drains,
And I'm squeezed through the bloody jaws of the killer cunt.
I'm dying in Shit Piss Blood.
Crushing walls vomit my bones
From the dark toward the light.
Ending attachment is the end of suffering,
Third noble truth.
Ahhhh! I am reborn
In time, to follow the Noble Path
That ends attachment and suffering.
Right view, right thought,
Right speech, right behavior,
Right livelihood, right effort,
Right mindfulness, right concentration.
Illuminated and liberated.
Unlimited good fortune.
I'll soon forget all this.
And then
I will remember.

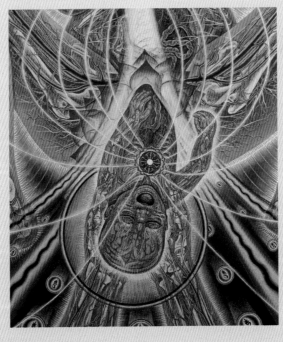

PROGRESS OF THE SOUL

We incarnate
And our body grows
And our consciousness evolves
From childhood magical myths and fantasies
To adult realities
But each one of us
Is a totally unique expression of universal creativity
We're each a form of God's art
In a cosmos of billions of galaxies
And in a galaxy of billions of stars
There's a planet with billions of people
The only one we know of
And every breath we breathe is a miracle
Our hearts pump
We see we hear we taste
We touch our world
And sometimes we forget
The pure wonder of our brief journey on Earth
But there are moments when we see
Behind the opaque curtain of life
When the infinite one shines
Through the skin of the beloved
And we see the game that we're in
The journey that we're on
The beautiful and powerful beings that we are
We get in touch with a truth
That's worth living for
Every moment of time is an opportunity
To reclaim our timeless essence
And every moment is an opportunity
To realize that we're all reflections of the divine
Beyond nationality race age gender
On our path of life
We each go through suffering
And joy
Each one of us learns life lessons
Private and ones to share
And each of us has family and friends
We need to let them know how much we love them
For all too soon we die
Our consciousness leaves our body
And our soul journeys into the great mystery

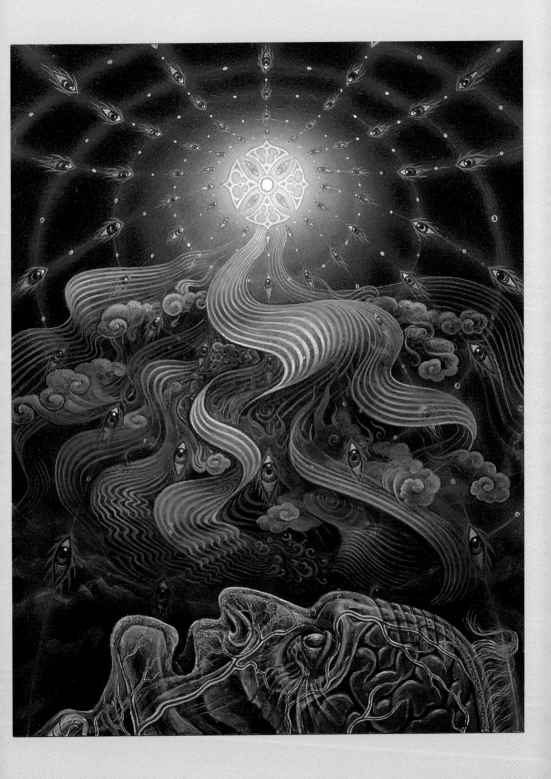

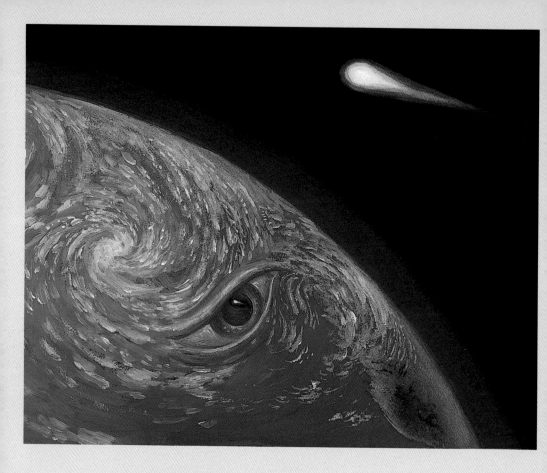

WorldSpirit Invocation

The WorldSpirit invocation is
A visualization practice we do together.
Hold your hands slightly apart,
Palms facing each other.
Begin to visualize a mass of light between your hands.
Just breathe deeply and relax.
You can close your eyes
And start to imagine rolling
A ball of light between your palms.

You're working with a luminous psychoplasma.
It can take any form that you can imagine.
So, using your imagination,
Just sculpt a small planet earth.
This complex, beautiful blue sphere
Covered with clouds, water, and land masses.
All of plant life growing.
All the creatures swimming, walking, flying.

The jungles, the deserts, the cities.
Focus your most powerful healing energy
On this small planet,
Creating a brighter, a better, more beautiful world,
And now insert that planet into your heart

Now using your imagination,
Project infinite beams of spiritual light
From your own heart center
Out to every being in every dimension on Earth,
Creating a luminous web
That links all beings.

We are all the humanity.
We are the animal spirits, we are the plant spirits,
We are the essence of the elements—earth, water, fire, air.

We are the vast web of
Interconnected energies and beings,
The spirit of the entire living planet.
We see ourselves as the radiant presence of the great
WORLDSPIRIT.

Allow us to use this blessed power
For a prayer of purification.

May the element of space in our bodies,
In our world, in our Kosmos,
Be pure from the beginning and throughout all time.

May the element of air in our bodies,
In our world, in our Kosmos,
Be pure from the beginning and throughout all time.

May the element of water in our bodies,
In our world, in our Kosmos,
Be pure from the beginning and throughout all time.

May the element of fire in our bodies,
In our world, in our Kosmos,
Be pure from the beginning and throughout all time.

May the element of earth in our bodies,
In our world, in our Kosmos,
Be pure from the beginning and throughout all time.

Space, air, water, fire, earth,
In our bodies, in our world, in our Kosmos.
Pure and clear, now and forever.

THE VAST EXPANSE

I acknowledge the privilege of being alive
In a human body at this moment,
Endowed with senses, memories, emotions, thoughts,
And the space of mind in its wisdom aspect.

It is the prayer of my innermost being
To realize my supreme identity
In the liberated play of consciousness,
The Vast Expanse.
Now is the moment,
Here is the place of Liberation.

Witness the contents of mind,
The visions, the sounds, the thoughts,
As clouds passing through the Vast Expanse,
The sky-like nature of mind.
The rootedness of Being is in emptiness, clarity, and awareness.
Unborn, unspoilt, stainlessly pure.

The infinite vibratory levels,
The dimensions of interconnectedness
Are without end.
There is nothing independent.
All beings and things are residents in your awareness.

I subject my awareness to the perfection of being,
The perfection of wisdom, and perfection of love,
All of these being co-present in the Vast Expanse.
I share this panorama of Being
And appreciate all I can share it with,
The seamless interweaving of consciousness
With each moment.

Create perfection wherever you go
With your awareness.
That is why this teaching is so admired by artists—
They sense the correctness of the response to life as creative.
Life is infinite creative joy.
Enjoyment and participation in this creative play
Is the artist's profound joy.
We co-author every moment
With universal creativity.
To bare our souls is all we ask,
To give all we have to life
And the beings surrounding us.

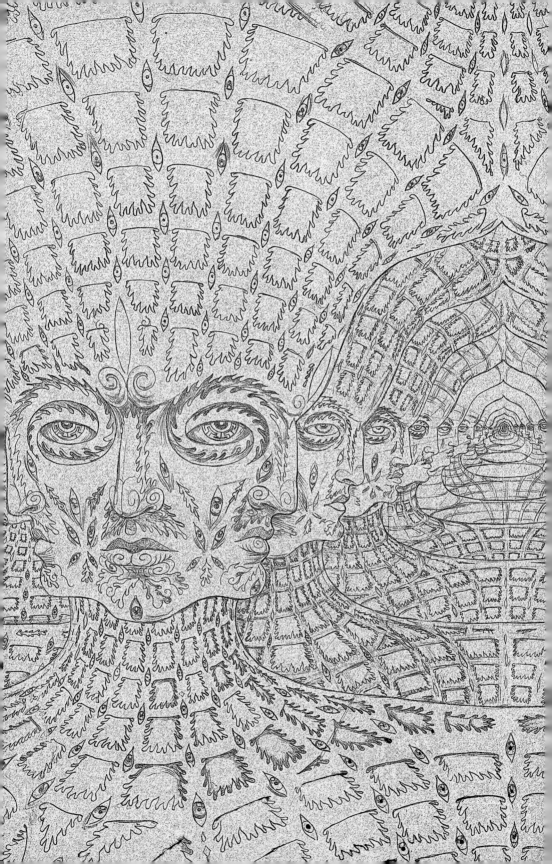

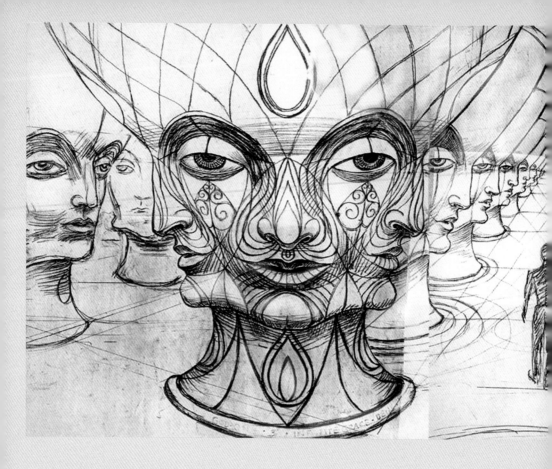

Here the nature spirits are intense
And we appreciate them, make offerings to them.
These nature spirits that call us here,
Sealing our fate with each other, celebrating our love.

I am an intersecting kaleidoscope of Being
In a rainbow refractive wave pattern:
A corpuscle of light on the ocean . . .
The transparency of my body with the rocks . . .
Sometimes the only way to summarize my feelings
Is to draw,
To collapse the frenzy in my limbs enough
To make a mark of appreciation
For my existence.

Share your presence with others, no boundaries—
Completely, lovingly, openly.
Love is what makes us alive,
That is why we feel so alive when we love.
Service is being available to love.

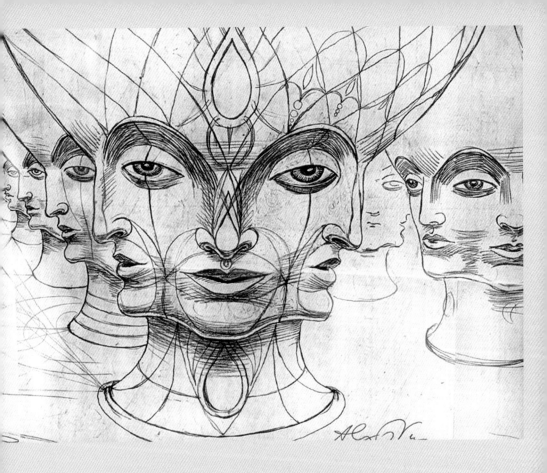

Life is the combustion of love.
We are constantly drawing the line between love and not-love.
Enter into the Non-duality Zone.
All judgements dissolve in the Vast Expanse.

It's as though we are
co-conspirators of consciousness
Everyone, everywhere, everywhen,
Mixing up our openable minds.
It's as though we could gather clouds in the sky
And people into our lives.
Like an eruption of consciousness,
We discover the source of love.
Discover yourself as the Source
And appreciate every moment as perfection.
Sunrise, Sunset. Thank you, Thank you,
Creator, Profound unstoppable connectedness of all beings,
Most radical no-thing,
The Vast Expanse.

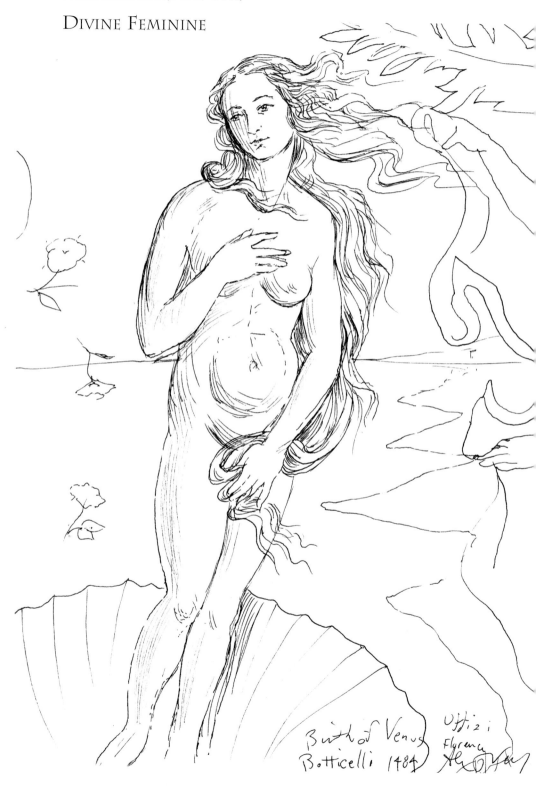

Birth of Venus
Botticelli 1484

Uffizi
Florence

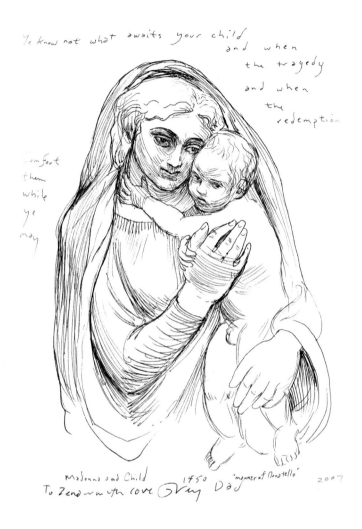

Ye know not what awaits your child
and when
the tragedy
and when
the
redemption

Comfort
them
while
ye
may

Madonna and Child 1450 "manner of Donatello" 2007
To Zeno with love Guy Dad

Beauty is a radiance of the extraordinary, the striking,
the authentic, the harmonious, that attunes us to divine
presence. The female figure is the most contemplated form
of beauty in the world. When beauty is threatened, heroic
rescue must be put into motion because the intrinsic value
of beauty is unquestionable, noble, and worth saving at any
cost.

Dawn. Woodstock School of Art
July 7, 1994
Alex Grey

Ayesha
Woodstock School 5 Art
7-5-96
Alex Grey

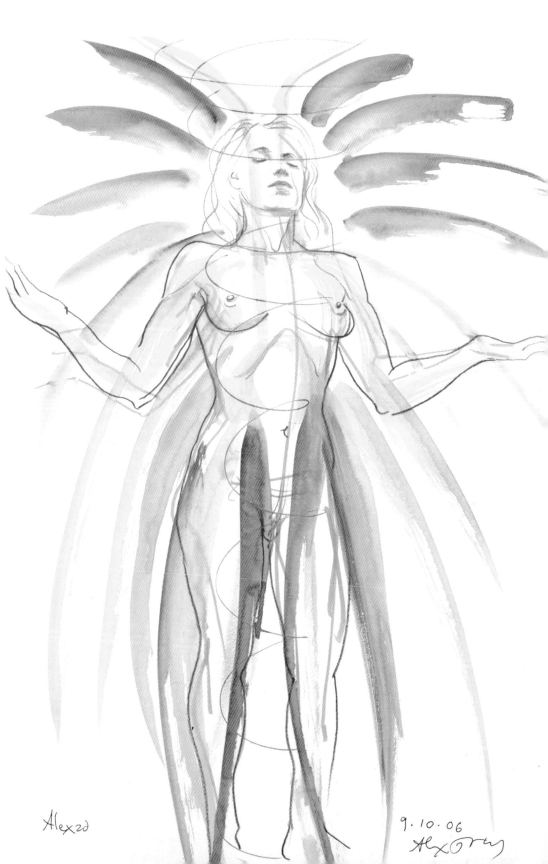

Alex2d

9.10.06

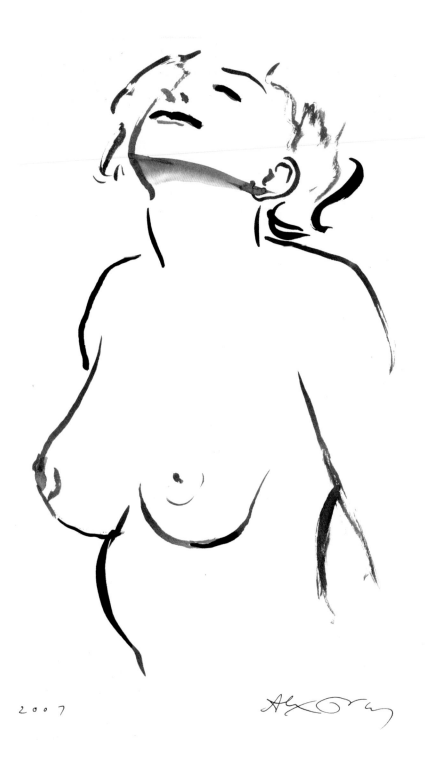

2007

136

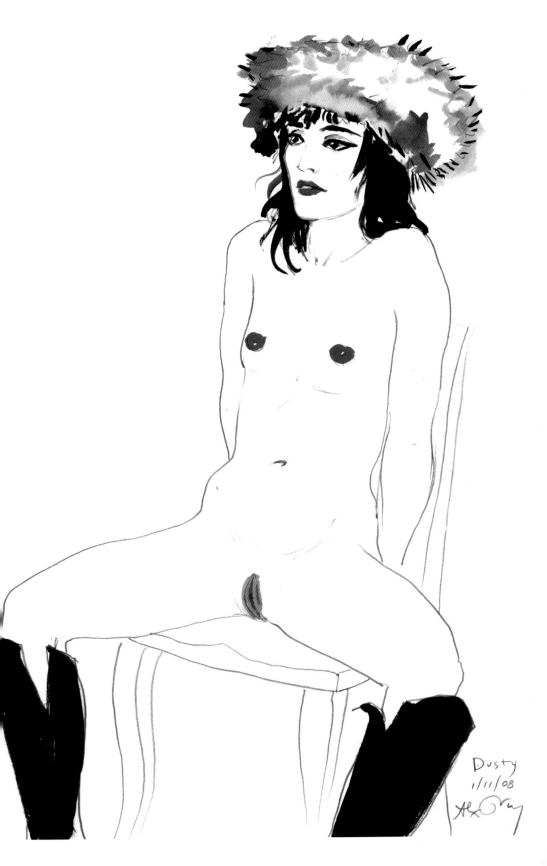

Dusty
1/11/08
Alx Gray

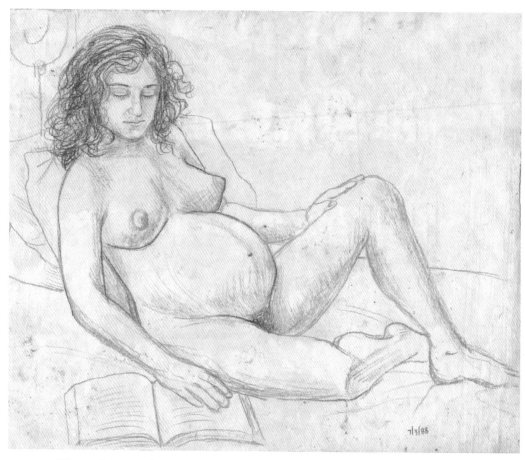

Allyson five months pregnant with Zena.

When Allyson was pregnant with Zena her body became a mysterious, alchemical flask of transformation.

As the two of us had become one in Zena, Allyson's oneness became twoness.

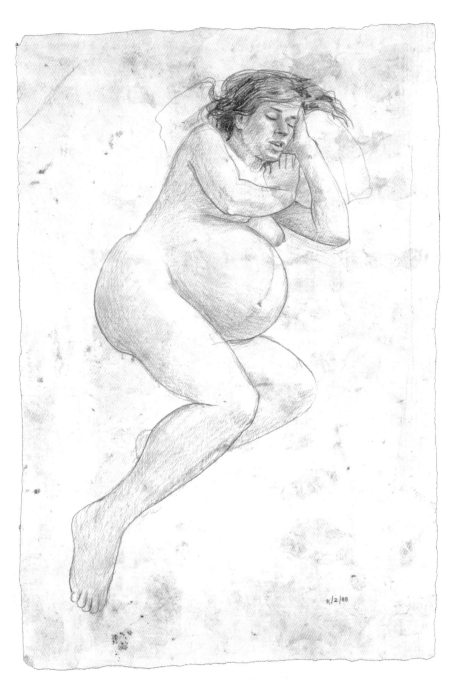

Allyson nine months pregnant with Zena.

Divine Feminine, I bow before thee,
Prostrate myself to thee,
Goddess circumference of the manifest,
O Mother, O Sister,
O Beloved Wife and Daughter,
Muse-whisperer inspiring us to
Greater Glory,
Attracting us Siren Sisters to
Seductress Shameless Sin.
Beauty is thy name,
Love is thy smoldering promise.
Thou art gateway to the world of Life
And dark door to the mysteries of Death.

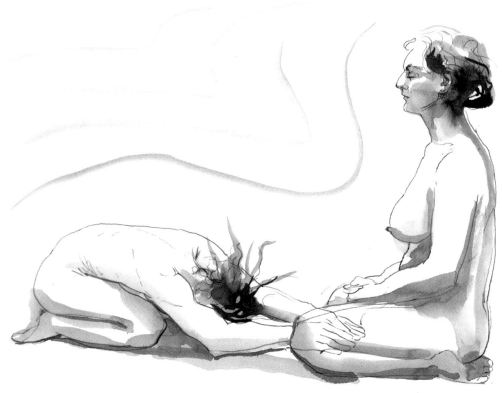

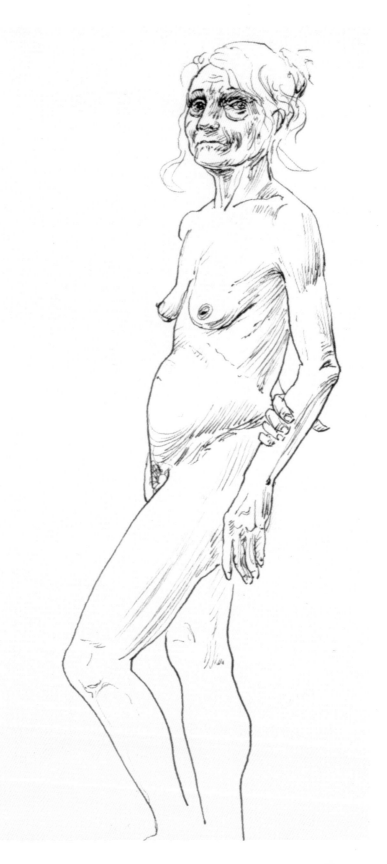

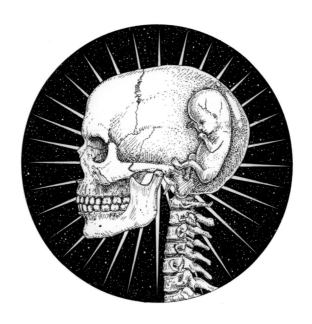

MEDITATIONS ON MORTALITY

Death hovers in the mind like an anticipated Grand Finale
In the fireworks display of our life.
We know it's coming.
We know it is the end of our bodily existence.
We know there is a light show.

Skull and skeleton are emblematic and ubiquitous
As symbolic reminders of our future.
Every dead person we see is us—soon enough.
The meditators in the charnel grounds
Watched rotting corpses
To embed the smelly lesson of impermanence in the mind.

Like a ticking clock "the skull grins in at the banquet"
And we see what we wish we had done.
Study death and celebrate your life
While you still host the holy ghost
That haunts your bones.

" what you are now
We once were —
what we are now
Is what you will become."

Capuchin Church
Rome Italy

6.7.07

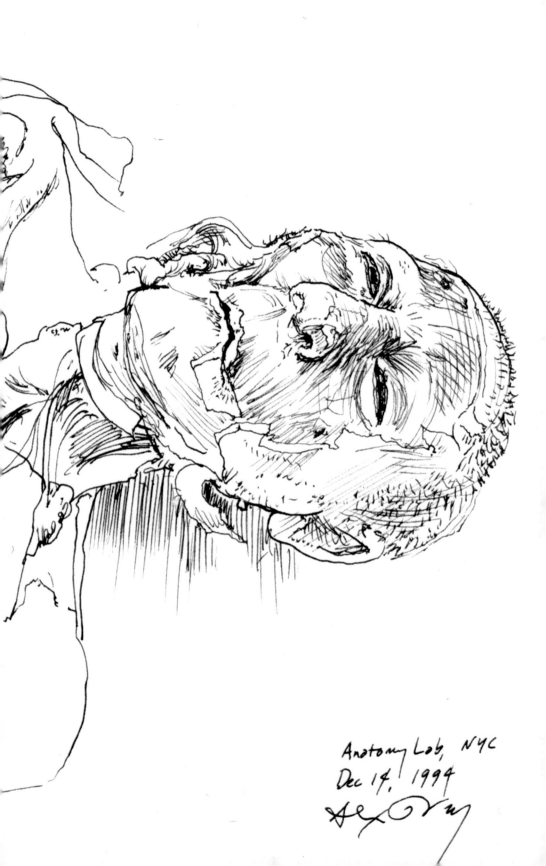

Anatomy Lab, NYC
Dec 14, 1994

Alex Grey
5.8.07
Anatomy Lab, N.J.

In honor of the most of the face

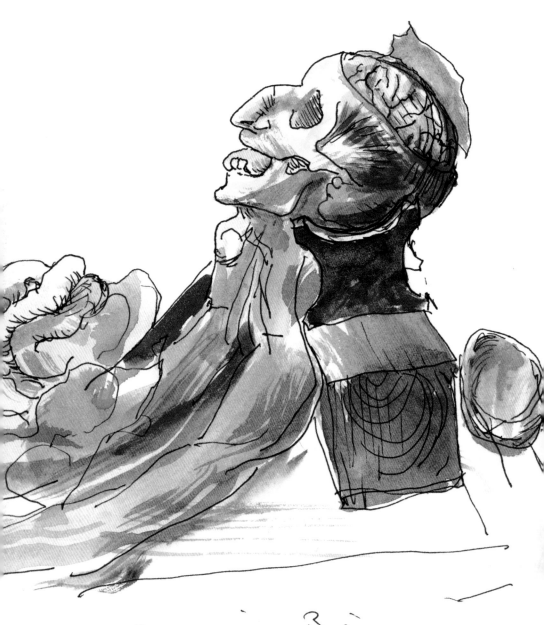

Comparing Brains

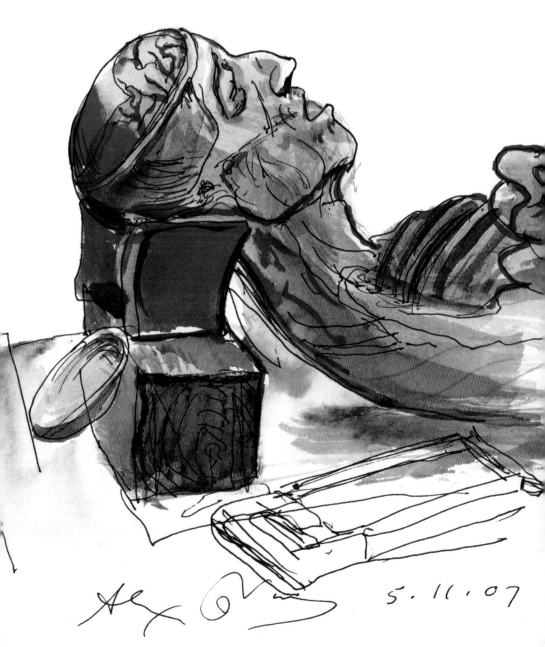

5.11.07

Rembrandthuis
11/22/2006 Amsterdam

MEDITATIONS ON THE MASTERS

How can one hear the voices of angels
And see their beauty, above the din of existence?
Sometimes one needs special antennae
To pick up the signals of the higher worlds.
The refinements of special meditations,
Seeing and drawing, and the entheogens,
Are just this.
But the point is not the practice or the drug,
But personal contact with the Divine.

Seeing is an activity,
An action channeling consciousness
Through the eyes,
Engaging the heights and depths of being.
Drawing is a seismography of the soul,
Capturing the waves of vision
Rippling through the self.
And why, beyond the viewing of
Michelangelo's body of work,
One needs any further evidence
For the existence of God
I do not know.

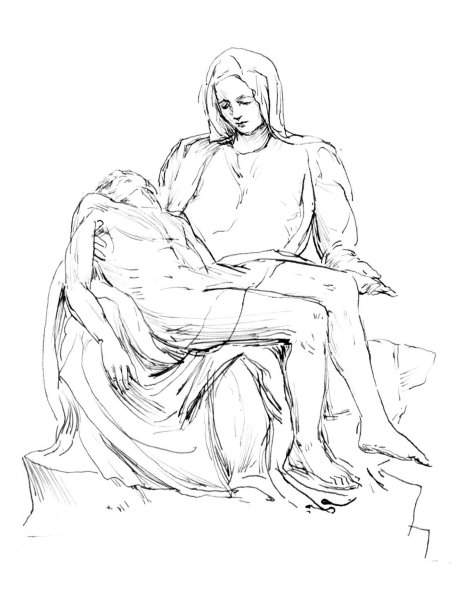

Pieta

St Peters
Vatican City
/6·6·07

Thankyou Michelangelo

Alex Grey

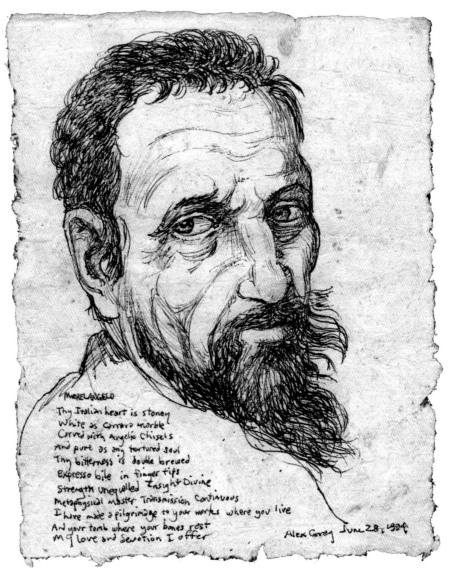

MICHELANGELO 1475–1564

Thy Italian heart is stoney
White as Carrara marble,
Carved with angelic chisels
And pure as any tortured soul.
Thy bitterness is double-brewed,
Espresso bile in fingertips.
Strength unequaled, insight divine,
Metaphysical master, transmission continuous.
I have made a pilgrimage to your works where you live
And your tomb where your bones rest,
Offering my love and devotion.

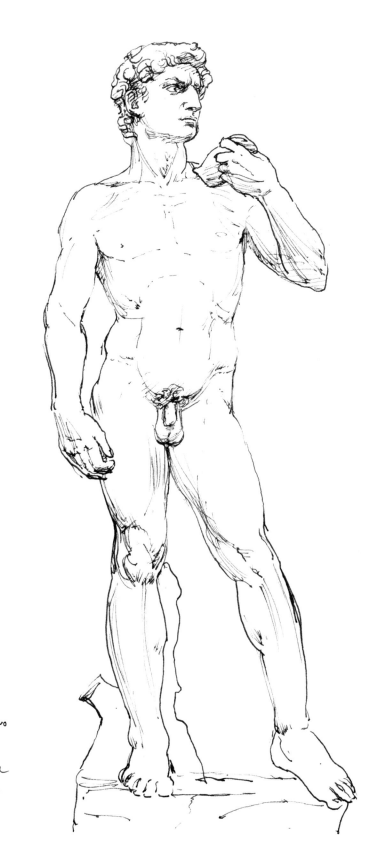

David michelangelo
June 19, 1994
Academy, Florence
Alex

SISTINE CHAPEL

The last successful Anthropocosm was here.
God as Human—Human as God.
Creator Father, inseminator of reality,
Divider of light and darkness,
Power and will of the divine,
Formed into a noble, muscular body.
Michelangelo
Always conveys feeling with form.
Every delicious and repulsive feeling
Is God when seen as energy.
The cosmos is the garment of the Creator.
The texture and pattern of the robe
Is all possible feeling and form.

The wonder and delusion
Of the Sistine Chapel
And most renaissance masterpieces
Is that now we are focused
Just as much on the mediator,
"Michelangelo" or "Leonardo,"
As on the God they painted.
Yet the degree to which
We see through their works
To the glories of heaven,
That is the value of their creations.

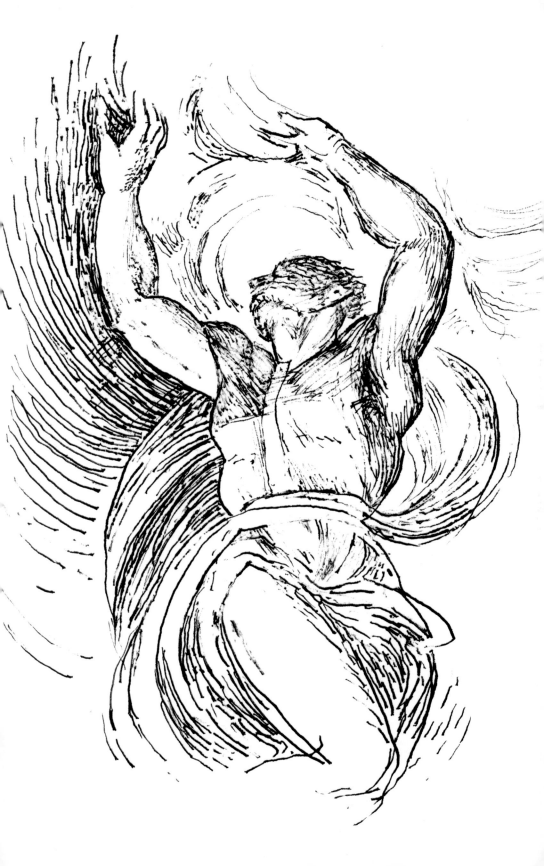

Last Judgment

The painting's revelatory power
Is not just a vision of futuristic
Apocalypse or an image of a tired dogma,
But an eternally relevant symbol of the magnitude
Of the journey of the soul.

Every moment is the Last Judgment.
We are challenged always to
Find the stillness of the heart of Christ
In the midst of rioting flesh,
Thundercloud masses of moving skin,
Tense and struggling with
The emotions of heaven and hell.
Even the heavenly elect are not at peace.
Christ is the hub, the eye of the meatstorm,
Compassionate witness to the ascent and descent
And the light of heaven.
Taoist center of a cyclonic yin yang.

Likened in scope to his Florentine brother, Dante,
And the Divine Comedy,
Michelangelo speaks to us
Visually/symbolically of the power of faith
To resurrect the Spirit.
The dead come to life and are clothed in a new spiritflesh
To experience life eternal by the power
Of their faith and choice of Christ as Savior.
When the trumpets blow,
A call that can be heard
At any moment, every moment,
Is the call to awaken, awaken and live
In the power of faith, the spiritual truth
God lives in every heart.
The saints and martyrs are already present
Next to Christ—their faith has placed them
In close proximity to the Lord.
They display the proof, the signs of their torment
And worthiness, how their faith was tested.
Likewise, the Last Judgment shows us how
Loss of faith results in the perversion and corruption,
The demonizing of souls.

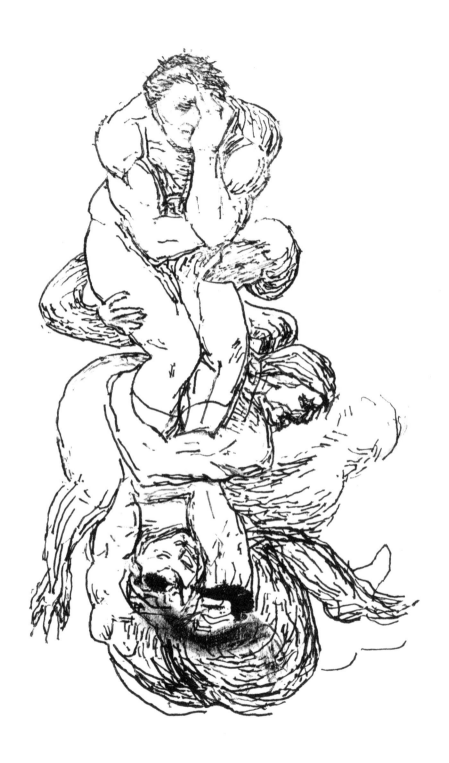

Whereas on the side of faith
The angels uplift the soul,
Wicked anger and doubt beat down the soul.
Eventually the gravity of regret and sin,
Lack of faith in God and the true self of Christ
Bring the lost soul to hell,
Where we are demonized, animalized,
Beaten by oarsmen and eaten by snakes
Of temptation and ill-will.
In a sense this is the death of the soul,
The loss of the soul,
Wandering in hell.
The skeletonizing underground of earth
Is a shamanic purgatory,
A catatonic trance of the soul,
A period of suspended animation
Where seeds of faith are sown.
Perhaps the hell-dwellers hear
The trumpet's call to awaken to faith
And resurrect, to join the grand round
Of tumultuous uplifting.

The only peace in the tumult of rounds
Through heaven and hell
Where faith is tested, broken
And resurrected anew through
The trials of life,
The only rest and comfort
Comes through identification
With the Christ Source.

From the view of Christ Consciousness
Last Judgement is the apocalyptic moment
Of giving up identity with Judging Mind,
Opening to the Non-duality
Of Heaven and Hell,
The Primordial Awareness underlying
Samsara and Nirvana.
The end of the world as we know it
Is an awakening to how all beings,
The elect and the damned, are God.

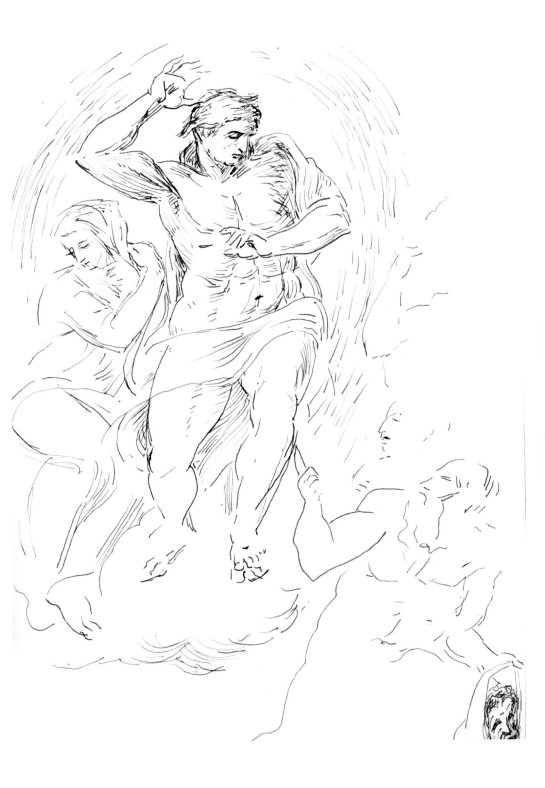

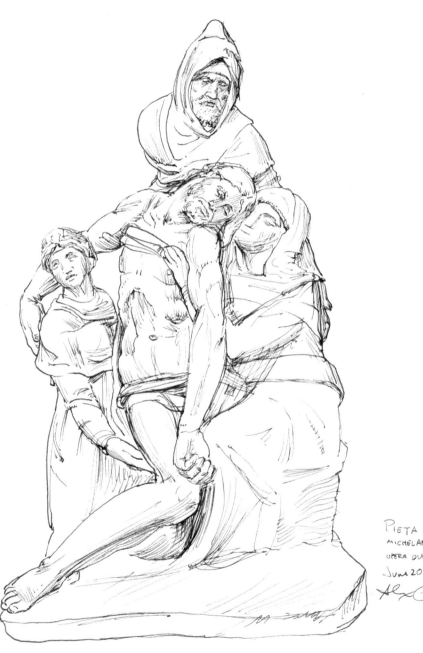

PIETA
MICHELANGIOLO
OPERA DUOMO, Florence
June 20, 1994

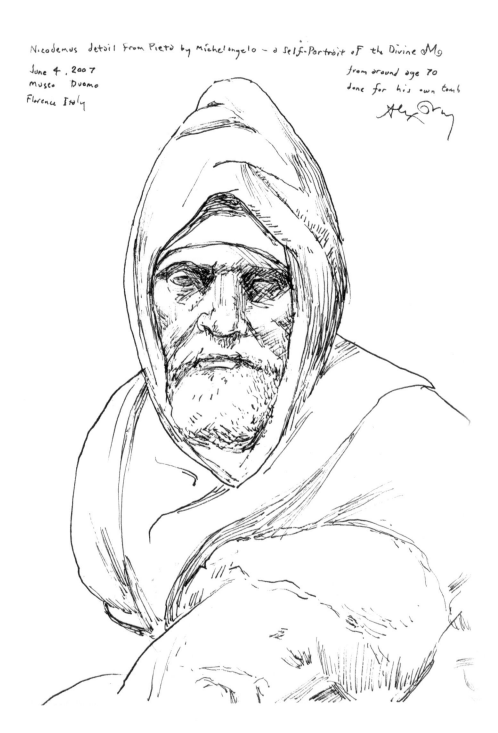

Nicodemus detail from Pietà by Michelangelo — a Self-Portrait of the Divine M.

June 4, 2007
Museo Duomo
Florence Italy

from around age 70
done for his own tomb

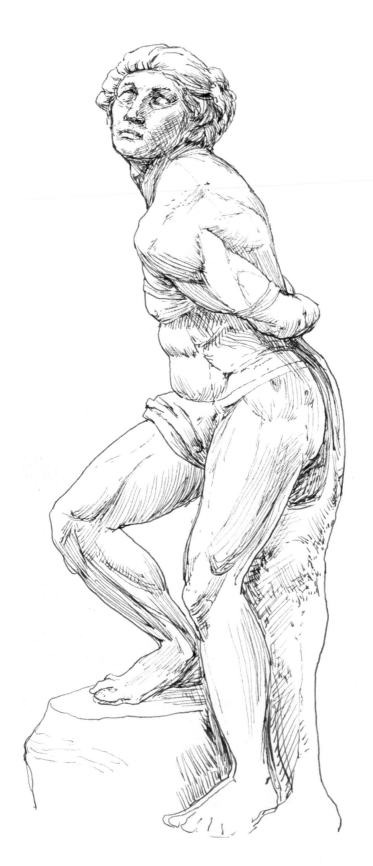

Captive
Michelangelo
1513-1515
Louvre, Paris
11/26/97
Alex Grey

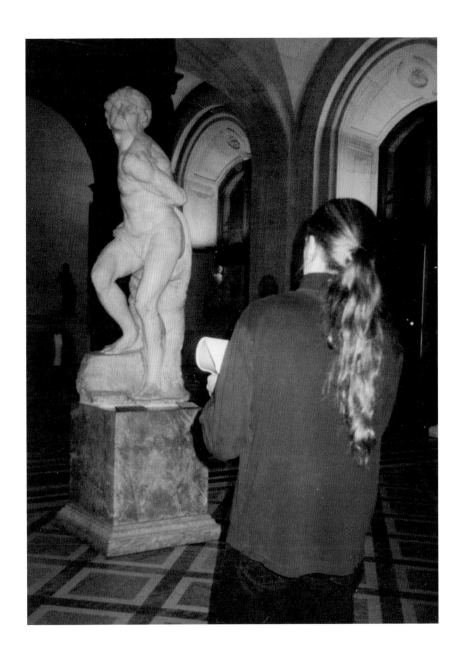

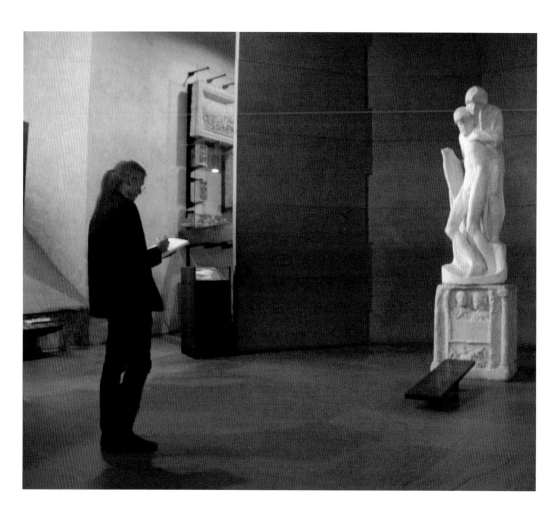

Drawing is a way to deepen the spiritual practice of seeing.
By following the contours of each shape and appreciating the
creative decisions of the masters, drawing becomes a form of
guru yoga, drawing into oneself the transmission of mastery.

Michelangelo's last Pieta is a strange, beautiful, and pitiful
thing. The sculpture seems unfinishable, its brokenness has
a pathetic yet modern quality. I am reminded of his late
drawings which are mostly crucifixions, very smudgy—they
hover like this sculpture in a rough-hewn ghostly hopeless grandeur.

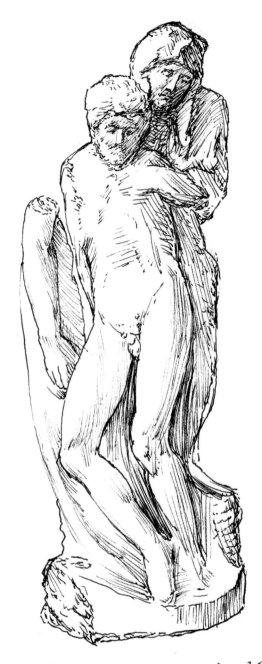

Pieta Rondanini

di
michelangelo Buonarroti

3 . 25 . 08
Milano

Rembrandt van Rijn
Self Portrait at an early age 1625?
Rijks Museum, Amsterdam

Alex Grey
11·25·95

REMBRANDT
1606–1669

Rembrandt van Rijn
Self Portrait
as the apostle Paul
1661

Rijks Museum, Amsterdam
November 25, 1795
Alex Grey

Rembrandt's self-portraits were his holiest offerings. The man truly knew and honored and forgave himself, allowing the Soul to peek through his adolescent and geriatric eyes, translating nobility into oil paint, mirroring our own timeless essence, the collective One Self of all great self-portraits.

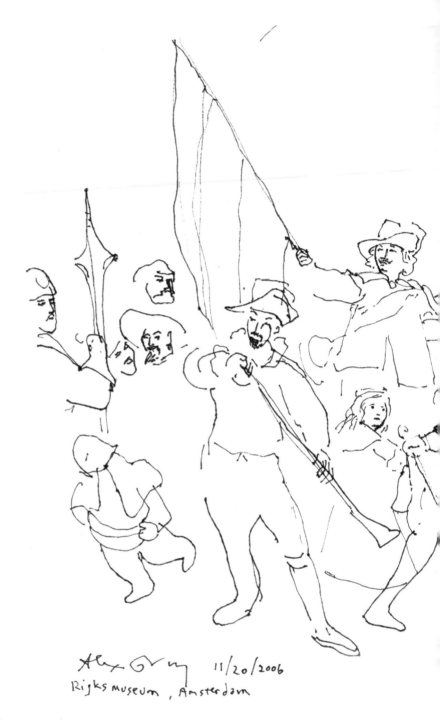

Alex Grey 11/20/2006
Rijksmuseum, Amsterdam

One of Rembrandt's most famous and largest paintings is called *The Night Watch*. This is a masterpiece of frozen dynamism, with a dog, a midget, and an old lady darting among the soldiers, and officials sauntering through the town square.

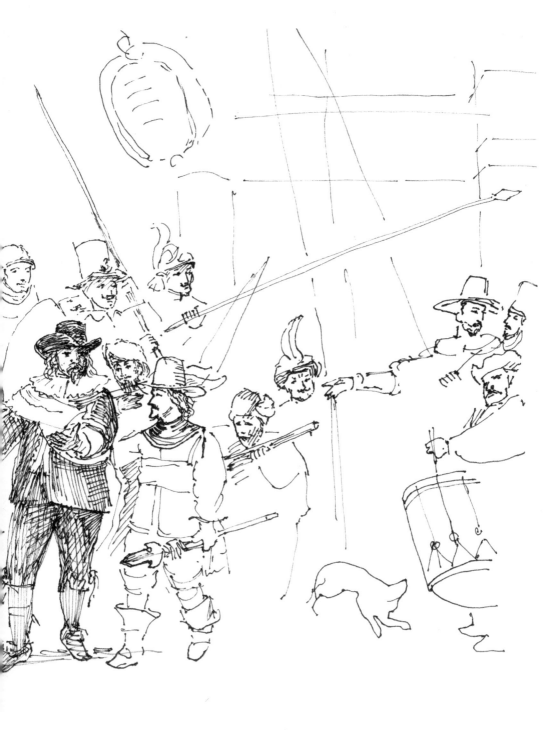

I particularly love how Rembrandt echoed the angled tilt of the
walking sticks, weapons, and flagpoles.

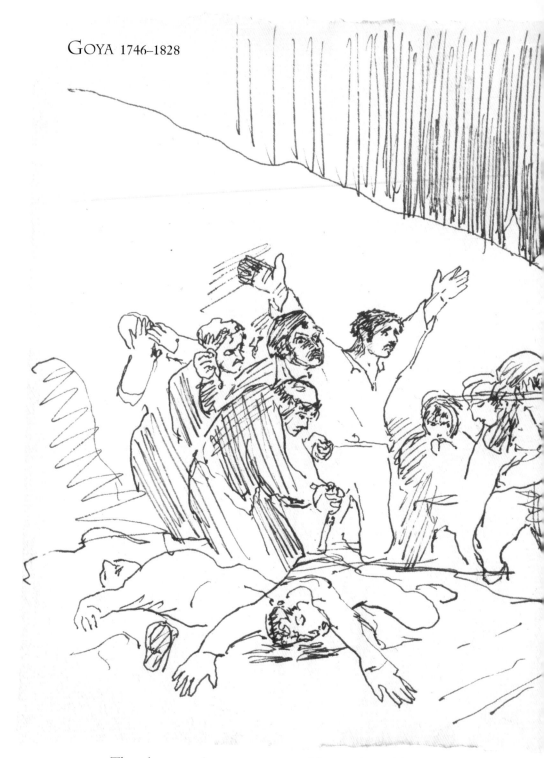

There has never been a more powerful evocation of the
helpless horror of war than the true nightmares of Goya.
The Third of May breaks your heart open.

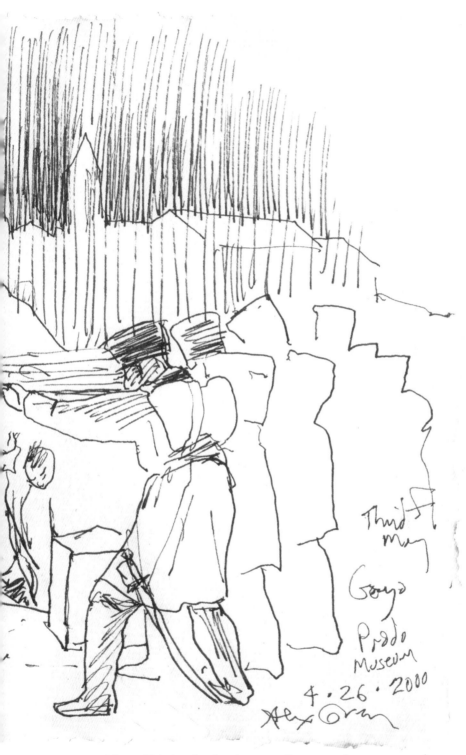

Third of
May

Goya

Prado
Museum

4 · 26 · 2000

Alex Orum

The militia is a faceless battery of guns, as the open-armed
soul of humanity pleads to stop the slaughter. The horror
is that the slaughter continues.

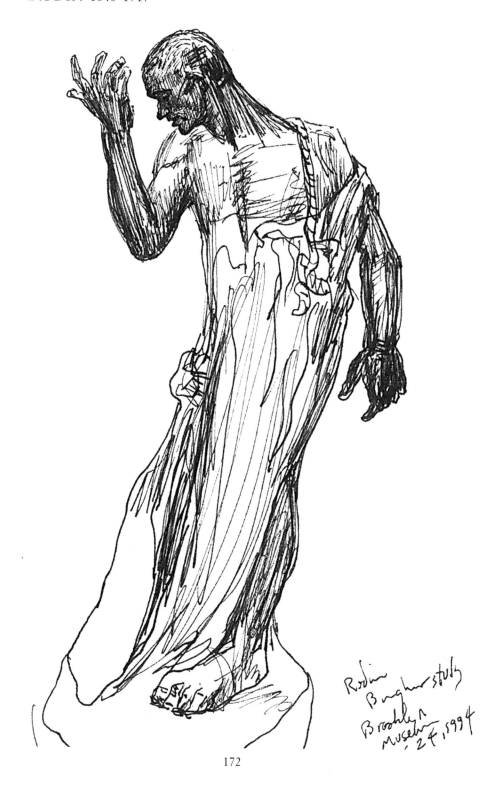

Rodin
Burghers study
Brooklyn
Museum
27, 1994

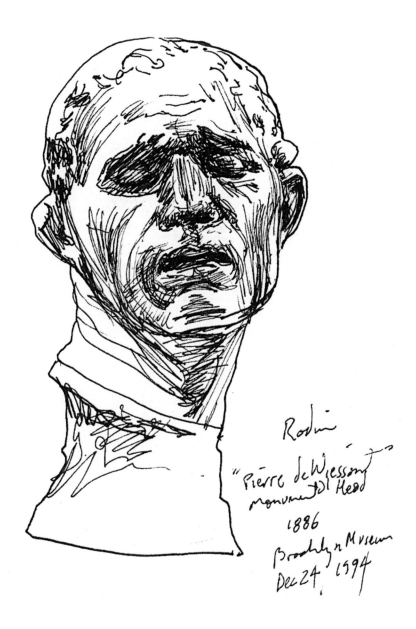

Rodin
"Pierre deWiessont
monument's Head
1886
Brooklyn Museum
Dec 24, 1994

*"Art is contemplation. It is the pleasure of the mind which
searches into nature and which there divines the spirit of
which nature herself is animated."*
—Auguste Rodin

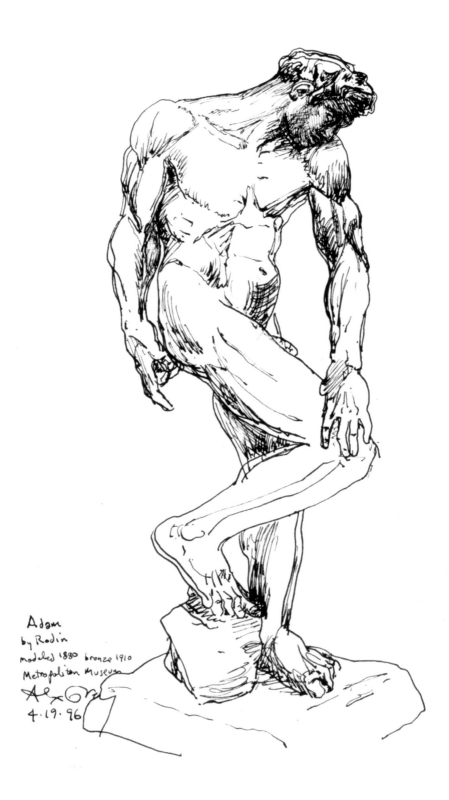

Adam
by Rodin
modeled 1880 bronze 1910
Metropolitan Museum

4·19·96

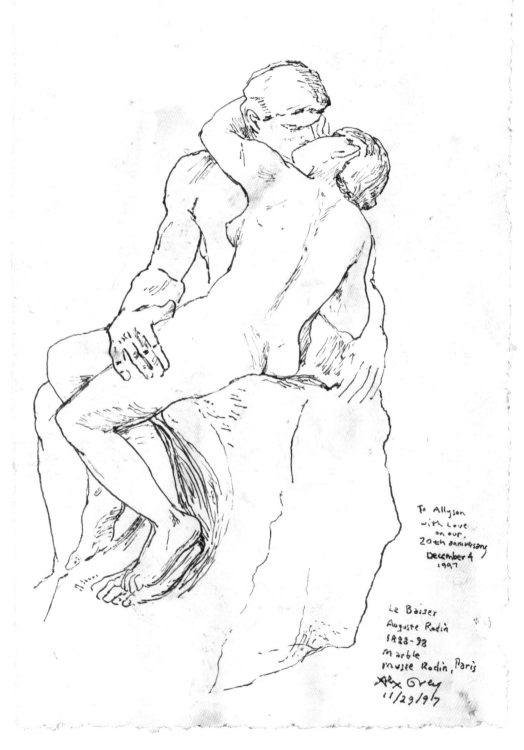

To Allyson
with Love
on our
20th anniversary
December 4
1997

Le Baiser
Auguste Rodin
1888-98
marble
musée Rodin, Paris
Alex Grey
11/29/97

Van Gogh
1853–1890

In Van Gogh's *Potato Eaters* we see a farming or peasant family dynamic. My fantasy goes like this: The son is fixated on winning the favor of the somewhat cruel matriarch, the wife can't get the son's attention. Father, holding the cup, is never satisfied yet always given honored treatment.

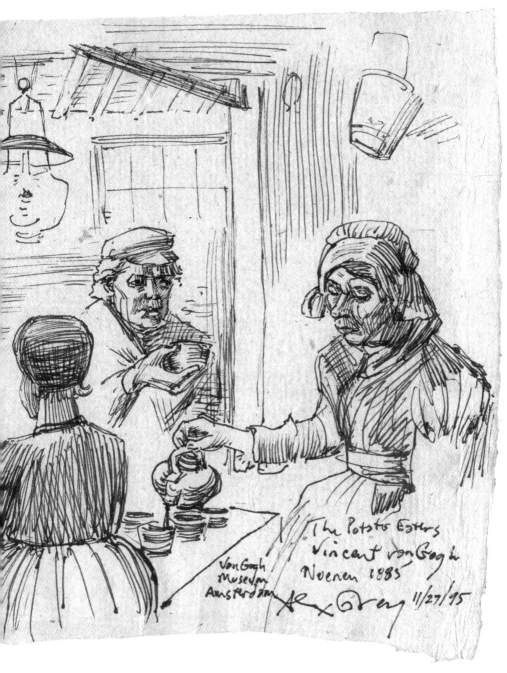

The Potato Eaters
Vincent van Gogh
Nuenen 1885

Van Gogh
Museum
Amsterdam

Alex Grey 11/27/95

All are neglecting the light of the family, the child directly under the lamp, a symbol of hope which no one seems to notice. Symbolically, the child is Vincent, the son is his brother Theo, and the woman looking at Theo is Theo's wife. (Note the painting over Theo's head—he was an art dealer.)

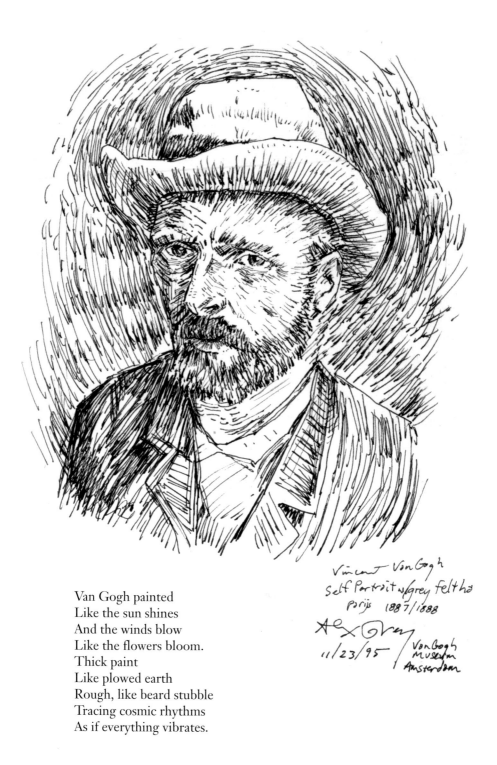

Van Gogh painted
Like the sun shines
And the winds blow
Like the flowers bloom.
Thick paint
Like plowed earth
Rough, like beard stubble
Tracing cosmic rhythms
As if everything vibrates.

Vincent Van Gogh
Self Portrait w/grey felt hat
Parijs 1887/1888
Alex Grey
11/23/95 / VanGogh
Museum
Amsterdam

vincent

Sunflowers 1889 Van Gogh Museum
Amsterdam 11/21/06 Alex Grey

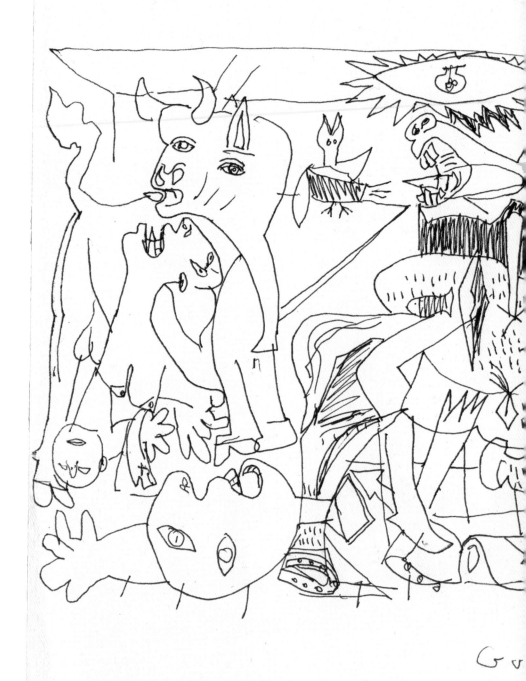

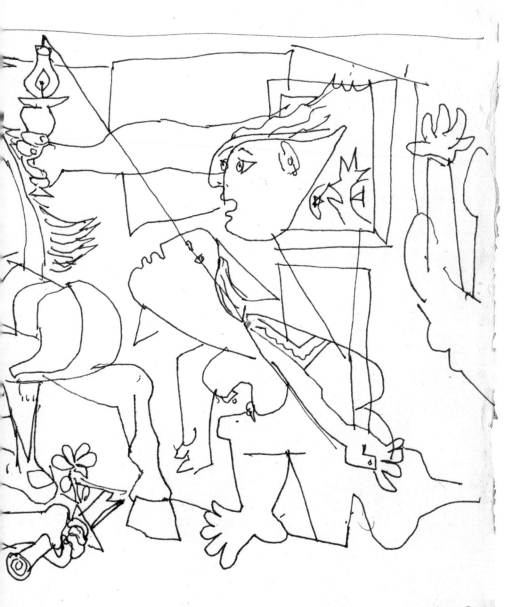

ruid Picasso Réma Sophia 4·27·2000

PICASSO
1881–1973

Picasso Reina Sofia 4.27.2000

As I drew in front of Picasso's *Guernica*, I asked him to teach me to see. I heard what I thought was Picasso's voice:

"You must devour each shape until it is in you and becomes you. Then you rip it apart and see what it is. Place the ripped shapes on a canvas. It is your flesh and blood because you live and breathe and eat every shape. Colors are the emotions; use them to bring tears or joy."

"*Guernica* was painted through me not by me. The demon spirit of Modernism used me, inhabited me, possessed me. And that is my life even in death. Become possessed. It is the only way to be great and live forever in your art. Now get to work! Remember to stick a fork in their eye and broken glass in their blood and they will remember you!"

26 Jun 1937 Picasso
4.27.2000 Reina Sofia

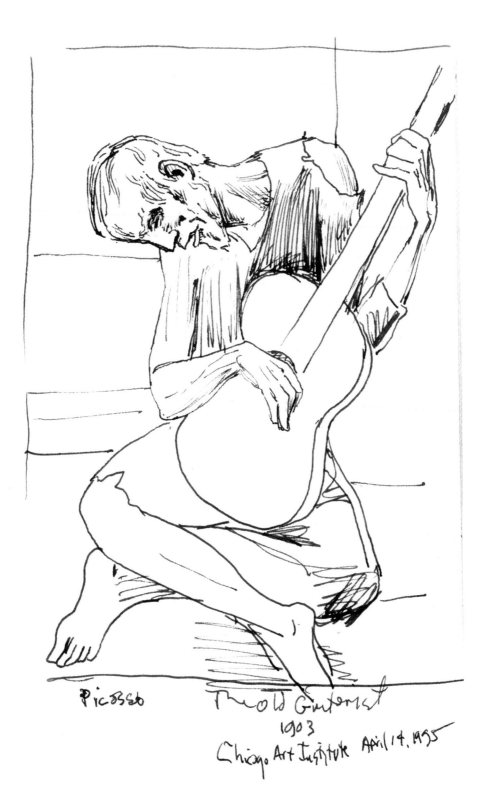

Picasso The old Guitarist
1903
Chicago Art Institute April 14, 1995

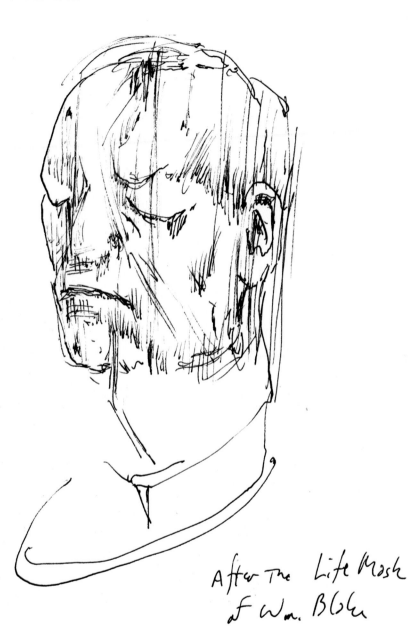

After The Life Mask
of Wm. Blake

Francis Bacon
1955

Bacon
Retrospective Milano 3·25·08

Francis Bacon, Andy Warhol, and Alex Grey at the opening of
Francis Bacon's retrospective at the Metropolitan Museum of Art, 1975.

*"The greatest art always returns you to the vulnerability of
the human situation."*

—Francis Bacon

CoSM and the Path of Art

THE MISSION OF THE CHAPEL OF SACRED MIRRORS, CoSM,
IS TO BUILD A TRANS-DENOMINATIONAL TEMPLE OF ART
AS AN ENDURING SANCTUARY OF UNIVERSAL SPIRIT
TO INSPIRE EVERY PILGRIM'S CREATIVE PATH
AND AFFIRM THE VALUES OF LOVE AND PERENNIAL WISDOM.

The letters CoSM relate to a realm or world,
Microcosm, Mesocosm, Macrocosm, Anthropocosm.

The original Greek word "kosmos"
Refers both to order and adornment.
The universe is a harmonious arrangement,
With a deep and beautiful order.
The stars are the ornament of heaven.
"Cosmetic" shares the root word "cosmos."
Adornment aligns the adorned with celestial order.
Art aligns the appreciator
With the ornamental beauty of the cosmos.
Ornament is human consciousness
Mirroring and expressing the abundance
Of creative Nature.
The Divine Imagination is overflowing
With numinous flora and fauna,
An endless well of patterns
Springing from a single paisley mustard seed,
Spirallically growing, interweaving, disobeying
The gravity of death and spreading
Via the visionary domain throughout world culture.
The inner realms undulate with infinite iridescent swirls,
And artists of all times, everywhere,
Labor to express a fragment of the fantastic richness.
Immerse in the elemental flow of life,
The cascade of rivers and clouds,
The rhythm of mountains and valleys,
The swirl of flames and galaxies.
Fractal wave-fronts
From both inner and outer worlds
Collide in the art of ornament.
The artist participates in the flow of universal creativity
That is both the adorning energy
And the order of the cosmos.

NEW MOON

Without a moon
The night sky is big and empty, like
Transcendental Voidness,
Our ultimate Ground of Being.
Meditating together
We align our Being with the "Witness,"
The deep background consciousness observing
The attributes of sensations,
emotions, thoughts, and desires
As objects arising in the bodymind,
Like reflections that pass through a mirror.
Hovering in the clarity of the Witness,
We evaluate our actions
And align with our highest possibilities.
Seeds of intention will grow
As the moon appears in the night sky.
We creatively plant our visions and intentions,
Outwardly manifesting our inspiration.

FULL MOON

The Full Moon,
Luminous circle in the sky,
Perfect symbol of our soul.
Archetypal shapes, sphere and circle,
Symbols of spiritual wholeness.
God is a circle
Whose circumference is boundless
And whose center is everywhere.
Full Moon, a Sacred Mirror,
Reflecting a greater light,
As our soul reflects the greater light of God.
Our being is bathed and baptized
In the milky moonlight.
Sacred gatherings on the Full Moon
Magnetically attract the ocean of love.
Declarations, commitments, and celebrations
Made on this monthly high tide of the spirit
Are aligned with heavenly forces.

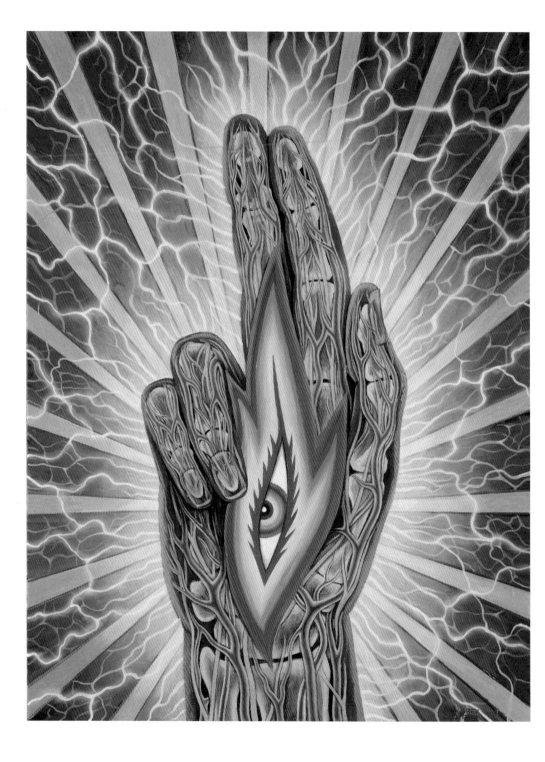

Guidance for Servants of God

BE THANKFUL FOR WHAT YOU HAVE.
Appreciate the here and now.
Recognize the precious opportunity of incarnation.

WATCH YOUR SPEECH.
Reduce or eliminate swearing and coarse, disrespectful words.
The same mouth will be used to speak for God.

HONOR THE BODY.
Eat, sleep, and care for your body mindfully, healthfully.
Curtail addictions. Curtail drug use.
Use sacraments in a sacred way. No casual use of sacraments.

LEARN TO PRAY, MEDITATE, AND CREATE.
Quiet the body, open the mind, unleash the soul.
Set aside time for your spiritual and creative life.

TREAT EACH OTHER WITH RESPECT AND KINDNESS.
No lying, stealing, cheating, hurting, or sexual misconduct.

PAY YOUR DEBTS.
This is essential for any business or relationship.

USE ENERGY WISELY.
Carefully manage physical, subtle, psychic and spiritual powers.

RESPECT PLANET EARTH AND ALL CREATION.
Support revitalization of the lifeweb and environment.

BECOME RECEPTIVE VESSELS OF A HIGHER POWER.
Align with the highest Truth, Goodness, and Beauty.

STUDY AND WALK A DEMANDING CREATIVE PATH WITH CONSCIOUSNESS AND CONSCIENCE.
Life is your ultimate artwork; make it a sacred offering.

God said,

I created the world to enact a drama.
Each of you has a role in the unfolding story.

Your job is to awaken each other to my presence.

But you must be firmly grounded
To be my representative,
Grounded in the Guidance
And all its ramifications.

Listen to all your brothers and sisters
As if they were me
And see if they correspond to Guidance given.

Respect Yourself.

Confess wrongdoing.
Ask Forgiveness.
Forgive others.
Surrender to Love.

Spiritual liberation is an ocean of Love.

Each being is a spring, stream, or rivulet
That journeys toward the ocean.

A powerful river is made by many streams.

The community is a river.
Join the river.
Remember the ocean and joyfully flow toward it.

In the greatest rivers,
The ocean flows inward according to the tide.

The worship of a community is like the tidal forces
That draw the ocean of Love
Upstream into the river.

A community can fuse with the Godforce
For enactment of a Divine Plan.

Sacred space is the work of a community.

Community needs Guidance.

EACH COMMUNITY MEMBER MUST APPLY THE GUIDANCE IN THEIR LIVES.

NOTHING IS ESOTERIC. THERE IS NO MAGIC.
DON'T BE LEAD ASTRAY BY THE OCCULT.
BEWARE THE DEAD END OF IDOLATRY.

CULTIVATE A HEART OF PURE LOVE.
EVERYTHING ELSE IS RUBBISH.

PERFORM ALL ACTS WITH A HEART OF PURE LOVE.

A HEART OF PURE LOVE IS MY GIFT TO YOU.

THERE IS NOTHING YOU CAN DO UNCEASINGLY,
EXCEPT TO LOVE GOD. ALL ELSE PASSES AWAY.

ALL HUNGERS AND DESIRES ARE FOR GOD.

FOOD, SEX, MONEY, DRUGS ARE ALL SUBSTITUTES
AND ONLY TEMPORARILY SATISFY.

GET CLEAR THAT YOUR DESIRE FOR GOD
IS THE ONLY SOURCE OF SATISFACTION.

TRUE PRAYER IS RESTING IN THAT DISCOVERY.

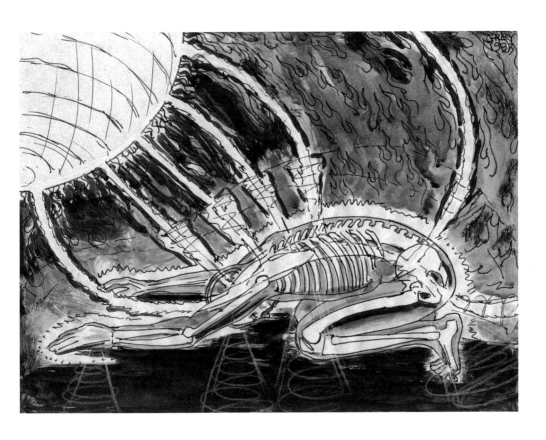

Why do I get depressed?

BECAUSE YOU ARE DELUSIONAL.

What do you mean?

YOU FORGET WHY I'VE SENT YOU HERE.
YOU HAVE SUBSTITUTED YOUR THINKING
FOR GENERATING A HEART OF PURE LOVE
AND PERFORMING ACTS FOR MY SAKE
AS AN EXPRESSION OF YOUR HEART, WHICH IS MINE.

WHEN YOU FALL UNDER THE SPELL OF THE SMALLER SELF,
YOU FORGET THAT I AM WITH YOU ALWAYS.

THE SMALL SELF IS A BUNDLE OF
JUDGEMENT, FEAR, ANGER, AND DESPAIR.
GROW UP AND TAKE THE MANTLE OF YOUR CALLING.
MARCH INTO LIFE. MY MANTLE PROTECTS THEE.

THE EMERALD MANTLE, THE HOLY MANTLE,
IS AN ENERGETIC PROTECTION VESTMENT
AND REVELATION THAT I AM WITH YOU.
WHEN YOU WEAR IT FOR MY SAKE,
WEAR IT OVER YOUR STREET CLOTHES,
AND I WILL SPEAK THROUGH YOU.

SPEAK NOT FOR EFFECT, ONLY FOR MEANING.
BE CLEAR AND LOVING.

UNDERSTAND, YOU ARE NOT SPECIAL.
ALL MY CHILDREN ARE MARVELOUS.
MY CHILDREN ARE ALL LIVING MIRACLES.

PERFORM ACTS FOR GOD'S SAKE.
PAINTING, EATING, EXCRETING—ALL IS ECSTATIC PRAYER.

WISDOM, COMPASSION, AND CREATIVE SERVICE ARE SOUL FOOD.

FEED THE TROOPS AS THEY MARCH TOWARD ME.

ALL ARE MARCHING TOWARD ME.

THE WORLD IS MY HEART OF PURE LOVE.

TO CHEAT, LIE, AND DISTORT THE TRUTH
IS ONLY IGNORANCE OF MY LAW.

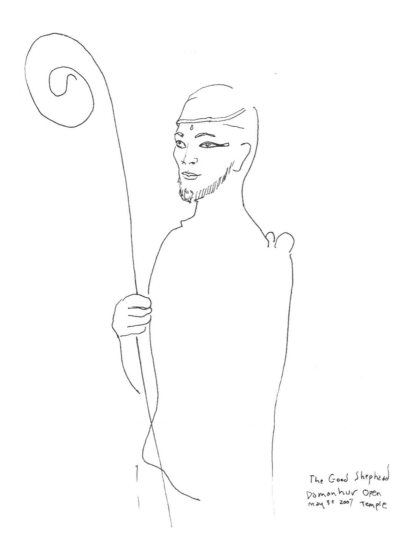

The Good Shepherd
Damanhur Open
May 30 2007 Temple

THE LAW IS AUTOMATIC IN A HEART OF PURE LOVE.

CULTIVATE FRIENDSHIP LIKE THE GARDEN IT IS,
FOR ALL ARE FED WHEN THE GARDEN IS CARED FOR AND NURTURED.

CELEBRATE LOVE AT SPECIAL TIMES.
TIME IS MY ROBE AND MY VEIL.

VENERATE YOUR PARENTS AND ANCESTORS.

LIVE AS THE IMPERISHABLE.

NOTE THE DAWN OF PLANETARY CONSCIOUSNESS—
DIM BUT INEVITABLE.

DEDICATION TO LOVE

From the core of our hearts
We dedicate ourselves
To the complete and full
Expression of Love
In all our activities
And in all our relationships.

Love is the soul's medicine,
A refuge in our hearts
Protecting us from utter despair.
Finding compassion in the eyes
Of the beloved and the stranger
Gives us the courage to endure.

May Love sensitize us
With care and wisdom.
May Love help heal the sickness
And wounds of life.
May Love enable us
To forgive and accept ourselves.

May Love enable us
To forgive and accept each other.
May Love help us overcome
Our cruelty and bitterness,
Our greed and jealousy,
Our ignorance and delusion.

May Love rule our hearts and minds,
Directing us to reach out,
Doing our best to benefit others,
To heal suffering, to give gifts,
To create beauty in the infinite network
That is our world.

A heart of loving-kindness
Pours creative grace into the world
To alleviate pain
And mend the heart net.
To the healing art of Love
We dedicate ourselves.

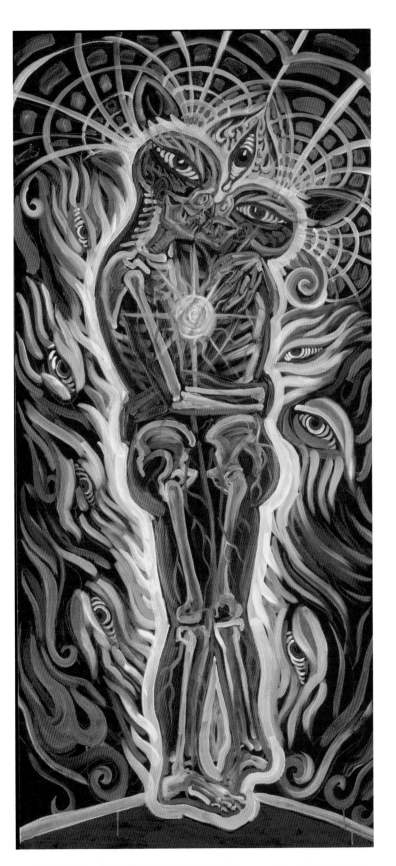

ALEX GREY
1953–

At age nine, while growing up in a Methodist household in Ohio, all my religious education and association ended abruptly. Incidents of hypocrisy and racism in our church during the civil rights movement of the '60s left my parents disenchanted with religion. Unmoored by loss of a spiritual rudder, I drifted into agnostic existentialism. My first LSD trip and meeting my wife, Allyson—two events occurring in a single night at age twenty-one—transformed my world-view into radical transcendentalism, permeated by divine love, and validating the mystic core of all wisdom paths.

Investigations into the nature of consciousness through shamanic performances in the '70s and '80s led me to practice Tibetan Buddhism and study the physical body. I got a job at a medical school morgue, preparing cadavers, and Allyson and I continued our psychedelic voyages. These sacramental sojourns led to artworks, including the SACRED MIRRORS, and other paintings that "X-ray" multiple dimensions of reality, interweaving physical and biological anatomy with psychic and spiritual energies. I applied this multidimensional perspective to painted visions of crucial human experiences, such as praying, kissing, copulating, pregnancy, birth, and dying, providing a glimpse into the luminous vibratory and archetypal domains of awareness described by healers, clairvoyants, and saints.

By referencing multiple wisdom traditions in my paintings, sculpture, and performances, the work points toward an inclusive vision of universal spirituality. A simultaneous inspiration has guided our life's work: to build a transdenominational temple and a home for visionary art. In 2004, Allyson and I founded the CHAPEL OF SACRED MIRRORS, CoSM, in New York, a cultural center celebrating a new alliance of divinity and creativity. With the help of many, the CHAPEL OF SACRED MIRRORS will be a legacy to inspire, inform, and illuminate the inexplicable for future generations.

Please visit www.alexgrey.com & www.cosm.org.

Art Index

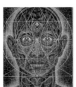
Dust Jacket
Human
Geometry
30 x 40 in.
acrylic on
Linen
2007

Endpapers
Sketch Book
Pages
9 x 12 in.
ink on paper
2003

Frontispiece
Photo of Alex
Reciting Poetry
at "One"
Performance
Los Angeles, CA
2005
by Pixie

Dedication
Seraphic
Drawing
5.5 x 8.5 in.
ink on
paper
2003

Contents
Arch Angels
Study
5.5 x 8.5 in.
ink on
paper
2003

Page 8
Holy Spirit
16 x 20 in.
acrylic
on wood
1998

Page 10
Cosmic
Consciousness
30 x 30 in.
acrylic on
canvas
2008

Page 12
Adam, Man,
Cosmos
6 x 6 in.,
10 x 10 in.,
16 x 16 in.
oil on
linen
1985

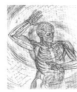
Page 14
Anthropocosm
8.5 x 10 in.
pencil on
paper
2007

Pages 16 & 17
Eye Corners
9 x 12 in.
pencil on
paper
2003

Page 18
Wheel of Life
10 x 12 in.
pencil on
paper
1995

Page 20
Grieving
9 x 12 in.
ink on
paper
2001

Page 21
Leaf and Tree
9 x 12 in.
ink on
paper
1974

Page 22
One
48 x 66 in.
oil on
linen
2000

Page 24
Despair
16 x 20 in.
acrylic on
linen
1996

Page 27
Painting
30 x 40 in.
oil on
linen
1998

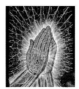
Page 28
Praying Hands
9 x 12 in.
acrylic on
paper
2008

Page 30
Primordial
Awareness
12 x 12 in.
acrylic on
canvas
2007

Page 32
TranscenDance
12 x 18 in.
pencil on
paper
2002

Page 34
Green Buddha
9 x 12 in.
pencil on
paper
2002

Page 36
New man IV
22 x 22 in.
acrylic on
paper
1980

Page 39
Anatomy
of the Eye
11 x 14 in.
acrylic on
paper
1993

Page 40
AHtist
14 x 10 in.
ink on
rice
paper
1997

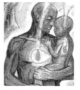
Page 43
Study for
Father & Child
11 x 14 in.
pencil & acrylic on
paper
2001

198

PAGE 45
VESPER
CHAKRA 5
11 x 14 IN.
ACRYLIC ON
PAPER
2003

PAGE 46
POLAR UNITY
SPIRAL
6 x 6 IN.
INK ON
PAPER
1986

PAGE 49
SKULL FETUS
STUDY
8 x 8 IN.
INK ON
PAPER
1979

PAGE 50
FERTILIZATION
8 x 8 IN.
DIGITALLY
ENHANCED
INK ON
PAPER
2001

PAGES 52 & 53
SHINTO
14-INCH RELIEF
2004

SUFISM
14-INCH RELIEF
2004

BAHA'I
14-INCH RELIEF
2004

HUNAB KU
14-INCH RELIEF
2004

HINDUISM
14-INCH RELIEF
2004

JUDAISM
14-INCH RELIEF
2004

ISLAM
14-INCH RELIEF
2004

PAGAN
14-INCH RELIEF
2004

SIKHISM
14-INCH RELIEF
2004

TAOISM
14-INCH RELIEF
2004

CHRISTIANITY
14-INCH RELIEF
2004

TIBETAN
BUDDHISM
14-INCH RELIEF
2004

ZOROASTRIANISM
14-INCH RELIEF
2004

BUDDHISM
14-INCH RELIEF
2004

WICCAN
14-INCH RELIEF
2004

JAINISM
14-INCH RELIEF
2004

PAGE 54
THE PROMISE
24 x 36 IN.
OIL ON
WOOD
1997

PAGE 56
ADAM & EVE
48 x 96 IN.
LINE WORK FROM
FRONT DOOR OF
CHAPEL OF
SACRED MIRRORS
2004

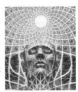

PAGE 59
ECSTASY
14 x 23 IN.
LITHOGRAPH
1993

PAGE 61
JIMMY IN
PRAYER
11 x 14 IN.
PENCIL ON
PAPER
1993

PAGE 63
DAWN OF
PLANETARY
CONSCIOUSNESS
30 x 40 IN.
ACRYLIC ON
LINEN
2007

PAGE 64
NATURE OF MIND
STUDY
PANEL 1
4 x 5 IN.
ACRYLIC ON
PAPER
1995

PAGE 66
NATURE OF MIND
STUDY
PANEL 2
4 x 5 IN.
ACRYLIC ON
PAPER
1995

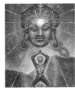

PAGE 68
NATURE OF MIND
STUDY
PANEL 3
4 x 5 IN.
ACRYLIC ON
PAPER
1995

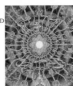

PAGE 72
NATURE OF MIND
STUDY
16.5 x 24 IN.
ACRYLIC ON
PAPER
1995

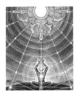

PAGE 72
NATURE OF MIND
STUDY
PANEL 5
4 x 5 IN.
ACRYLIC ON
PAPER

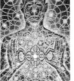

PAGE 74
NATURE OF MIND
STUDY
PANEL 6
4 x 5 IN.
ACRYLIC ON
PAPER
1995

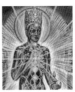

PAGE 76
NATURE OF
MIND
STUDY
PANEL 7
4 x 5 IN.
ACRYLIC ON
PAPER

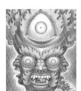

PAGE 78
WRATHFUL
GUARDIAN
11 x 14 IN.
PENCIL ON
PAPER
1995

PAGE 81
GUARDIAN OF THE
ENDLESS SMILE
11 x 14 IN.
PENCIL ON
PAPER
1980

PAGE 82
GUARDIAN OF
INFINITE VISION
11 x 14 IN.
PENCIL ON
PAPER
1980

PAGE 85
MASTER OF
CONFUSION
11 x 14 IN.
PENCIL ON
PAPER
1981

PAGE 86
DHARMA MOTH
11 x 14 IN.
INK ON
PAPER
2000

PAGE 88
SHAMAN'S
DREAM
11 x 14 IN.
PENCIL ON
PAPER
1986

PAGE 90
CANNABACCHUS
24 x 30 IN.
OIL ON
WOOD
2006

PAGE 92
PRAYING
8 x 8 IN.
PRINTED
PERFORATED
PAPER
(PIRATE BLOTTER)

PAGE 94
HYPER
DIMENSIONAL
INSECTOID
11 x 14 IN.
PENCIL ON
PAPER
1998

PAGE 97
FUCKING
DRAGONS
30 x 40 IN.
ACRYLIC ON
LINEN
2006

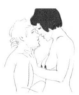

PAGE 98
COUPLE
11 x 14 IN.
PENCIL & ACRYLIC
ON PAPER
2008

PAGE 100
FUCKING
10 x 12 IN.
INK ON PAPER
2001

PAGE 102
FUCKING
DRAGONS
11 x 14 IN.
INK ON
PAPER
1986

PAGE 104
FEATHERED
SERPENT
11 x 14 IN.
INK & ACRYLIC
ON PAPER
2001

PAGE 107
CHRIST WITH AN
INTERFAITH
HEART
11 x 14 IN.
ACRYLIC ON
PAPER
1999

PAGE 108
WORLDSPIRIT
PERFORMANCE
SWEET'S BALLROOM
OAKLAND, CA
2003

PAGE 109
WORLDSPIRIT
PERFORMANCE
ON STAGE:
ALEX & ALLYSON
GREY &
KENJI WILLIAMS
2003

PAGE 109
AUDIENCE AT
WORLDSPIRIT
PERFORMANCE
2003

PAGE 110
EARTH ENERGIES
30 x 18 IN.
ACRYLIC ON
PAPER
1986

PAGE 113
FEAR (DETAIL)
96 x 96 IN.
ACRYLIC ON
CANVAS
1986

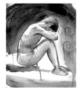

PAGE 115
DESPAIR
11 x 14 IN.
WATERCOLOR ON
PAPER
2006

PAGE 117
HOPE (DETAIL)
96 x 96 IN.
ACRYLIC ON
CANVAS
2006

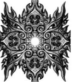

PAGE 118
BUDDHA EMBRYO
DIGITAL PAINTING
2001

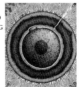

PAGE 119
FERTILIZATION
8 x 8 IN.
DIGITALLY ENHANCED
INK DRAWINGS ON
CANVAS
1986

BUDDHA
ZYGOTE
8 x 8 IN.
2001

TWENTY-
FIVE DAYS
8 x 8 IN.
2001

MORULA
8 x 8 IN.
2001

FIFTY-TWO
DAYS
8 x 8 IN.
2001

MITOSIS I
8 x 8 IN.
2001

THIRTY-
FIVE DAYS
8 x 8 IN.
2001

BLASTOCYST
8 x 8 IN.
2001

SIXTEEN
WEEKS
8 x 8 IN.
2001

MITOSIS II
8 x 8 IN.
2001

FORTY
DAYS
8 x 8 IN.
2001

PAGE 121
BIRTH (DETAIL)
44 x 60 IN.
OIL ON
LINEN
1990

PAGE 123
THE SOUL
FINDS ITS WAY
11 x 14 IN.
2001

PAGE 124
EARTH
CONSCIOUSNESS
(DETAIL FROM
COSMIC CHRIST)
5 x 7 IN.
OIL ON WOOD
2000

PAGE 126
STUDY FOR
NET OF BEING
16 x 32 IN.
PENCIL ON PAPER
2003

PAGES 128 & 129
STUDY FOR THE
HALL OF BEING
10 x 30 IN.
PENCIL ON
PAPER
2003

PAGE 130
STUDY OF
BOTTICELLI'S
VENUS
11 x 14 IN.
INK ON
PAPER
2007

PAGE 131
MADONNA &
CHILD
11 x 14 IN.
INK ON
PAPER
2007

PAGE 132
DAWN
11 x 14 IN.
INK ON
PAPER
1994

PAGE 134
AYESHA
11 x 14 IN.
INK ON
PAPER
1996

PAGE 135
ALEXZA
11 x 14 IN.
ACRYLIC ON
PAPER
2006

PAGE 136
WOMAN
11 x 14 IN.
INK ON
PAPER
2007

PAGE 137
DUSTY
11 x 14 IN.
PENCIL & ACRYLIC
ON PAPER
2008

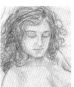

PAGE 138
ALLYSON
PREGNANT &
READING
12 x 16 IN.
PENCIL ON
PAPER
1988

PAGE 139
ALLYSON
PREGNANT &
SLEEPING
15.5 x 23 IN.
PENCIL ON
BARK PAPER
1988

PAGE 140
PROSTRATION TO
THE GODDESS
11 x 14 IN.
INK ON
PAPER
1999

PAGE 141
AGED LADY
11 x 14 IN.
INK ON
PAPER
1999

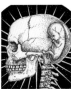

PAGE 142
SKULL FETUS
8 x 8 IN.
INK ON
PAPER
1979

PAGE 143
CAPUCHIN
CHURCH
11 x 14 IN.
INK ON
PAPER
2007

PAGE 144
ANATOMY LAB
11 x 14 IN.
INK ON
PAPER
1994

PAGES 146 & 147
MASK OF
THE FACE
11 x 14 IN.
INK ON
PAPER
2007

PAGES 148 & 149
COMPARING
BRAINS
11 x 14 IN.
INK &
WATERCOLOR
ON PAPER
2007

PAGE 150
REMBRANDT'S
EASEL
11 x 14 IN.
INK ON
PAPER
2006

PAGE 151
STUDY OF
MICHELANGELO'S
PIETA
11 x 14 IN.
INK ON
PAPER
2007

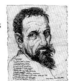

PAGE 152
MICHELANGELO
11 x 14 IN.
INK ON
BARK PAPER
1994

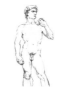

PAGE 153
STUDY OF
MICHELANGELO'S
DAVID
11 x 14 IN.
INK ON
PAPER
1994

PAGE 155
STUDY OF
*GOD SEPARATING
LIGHT FROM
DARKNESS*
11 x 14 IN.
INK ON PAPER
2007

PAGE 157
STUDY OF
MICHELAGELO'S
DAMNED SOUL
11 x 14 IN.
INK ON
PAPER
11 x 14 IN.

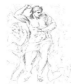

PAGE 159
STUDY OF
MICHELANGELO'S
LAST JUDGEMENT
11 x 14 IN.
INK ON
PAPER
2007

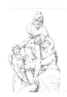

PAGE 160
STUDY OF
MICHELANGELO'S
PIETA
11 x 14 IN.
INK ON
PAPER
1994

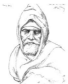

PAGE 161
STUDY OF
MICHELANGELO'S
*PORTRAIT OF
NICODEMUS*
11 x 14 IN.
INK ON
PAPER

PAGE 163
STUDY OF
MICHELANGELO'S
CAPTIVE
11 x 14 IN.
INK ON
PAPER
1997

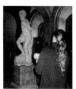

PAGE 164
ALEX DRAWING
MICHELANGELO
CAPTIVE
PHOTO BY
ALLYSON GREY
1997

PAGE 164
ALEX DRAWING
MICHELANGELO'S
PIETA RONDANINI
PHOTO BY
ZACHARIAH
GREGORY
2008

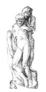

PAGE 165
STUDY OF
MICHELANGELO'S
PIETA RONDANINI
11 x 14 IN.
INK ON
PAPER
2008

PAGE 166
STUDY OF
*REMBRANDT
SELF-PORTRAIT*
11 x 14 IN.
INK ON
PAPER
1995

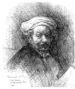

PAGE 167
STUDY OF
*REMBRANDT
SELF-PORTRAIT
AS PAUL*
11 x 14 IN.
INK ON PAPER
1995

PAGE 168
STUDY OF
REMBRANDT'S
THE NIGHT WATCH
11 x 14 IN.
INK ON
PAPER
2006

PAGE 170
STUDY OF GOYA'S
*THE THIRD OF
MAY*
11 x 14 IN.
INK ON
PAPER
2000

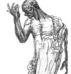

PAGE 172
STUDY OF RODIN'S
BURGHER
5.5 x 8.5 IN.
INK ON
PAPER
1994

PAGE 173
STUDY OF RODIN'S
PIERRE DE WIESSANT
5.5 x 8.5 IN.
INK ON
PAPER
1994

PAGE 174
STUDY OF RODIN'S
ADAM
9 x 12 IN.
INK ON
PAPER
1996

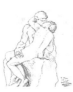

PAGE 175
STUDY OF RODIN'S
THE KISS
9 x 12 IN.
INK ON
BARK PAPER
1997

PAGES 176 & 177
STUDY OF
VAN GOGH'S
POTATO EATERS
9 x 12 IN.
INK ON
BARK PAPER
1995

PAGE 178
STUDY OF
VAN GOGH
SELF-PORTRAIT
9 X 12 IN.
INK ON
PAPER
1995

PAGE 179
STUDY OF
VAN GOGH'S
SUNFLOWERS
5.5 X 8.5 IN.
INK ON
PAPER
1986

PAGES 180 & 181
STUDY OF
PICASSO'S *GUERNICA*
11 X 14 IN.
INK ON
PAPER
2000

PAGE 182
STUDY OF PICASSO'S
CRYING WOMAN
5.5 X 8.5 IN.
INK ON
PAPER
1986

PAGE 182
STUDY OF PICASSO'S
CRYING WOMAN
5.5 X 8.5 IN.
INK ON
PAPER
1986

PAGE 183
STUDY OF PICASSO'S
THE OLD GUITARIST
5.5 X 8.5 IN.
INK ON
PAPER
1986

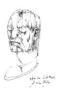
PAGE 184
WM. BLAKE BY
FRANCIS BACON
BY ALEX GREY
11 X 14 IN.
INK ON
PAPER
2008

PAGE 185
BACON, WARHOL,
& GREY
METROPOLITAN
MUSEUM OF ART
PHOTO BY
SCOOTER McDOODY
1975

PAGE 186
ALEX & ALLYSON GREY
LIVE PAINTING
SAN FRANCISCO, CA
PHOTO BY ELI MORGAN
2007

PAGE 188
BLESSING
30 X 40 IN.
ACRYLIC ON
LINEN
2008

PAGE 191
STUDY FOR
PROSTRATION
8.5 X 11 IN.
INK ON
PAPER
1993

PAGE 193
THE GOOD SHEPHERD
11 X 14 IN.
INK ON
PAPER
2007

PAGE 195
THIRD FORCE
36 X 84 IN.
ACRYLIC ON
WOOD
2005

PAGE 197
SELF-PORTRAIT AT
AGE 54
11 X 14 IN.
INK ON
PAPER
2008

Also Available from Alex Grey

SACRED MIRRORS: THE VISIONARY ART OF ALEX GREY

TRANSFIGURATIONS

THE MISSION OF ART

CoSM, CHAPEL OF SACRED MIRRORS
by Alex and Allyson Grey

on DVD & CD

CoSM: THE MOVIE

WORLDSPIRIT

ART AS SPIRITUAL PRACTICE

ART MIND:
THE HEALING POWER OF SACRED ART

THE VISIONARY ARTIST:
ALEX GREY'S VISUALIZATIONS FOR CREATIVE EXPLORATION

Available from CoSM Press

DAMANHUR: TEMPLES OF HUMANKIND

SACRED MIRRORS CARD SET

CoSM JOURNAL OF VISIONARY CULTURE

Santa Anna

1. original blessing
"Remember that you are blessed"
We won the physical battles of Sacred Geometry
We are meeting each other on the portals of Sacred Geometry
2.

Seraphic Triangle

Chagdud Tulku
Jellied Grooming Long
For Dzogchen
teaching Nam Jong
open Center
NYC
march, '97

drill press to Heaven

Granite head - Grotto.
A black madonna was kept in
the Grotto from fall to Spring
out from Spring to Fall.

Vates - celtic tradition

Vate canos mans - gathering of
Expectation of Birth Oracles.